D0865654

I need to raise £5,000 in a week.
I have nothing to sell, and nothing to borrow against. Any ideas?

I need to raise £5,000 in a week. I have nothing to sell, and nothing to borrow against. Any ideas?

If you don't own anything you can sell, sell something you don't own. I would scour London's street markets that specialize in antiques, jewellery and knick-knacks and take photos of the ten items you think stand out as looking very sellable, and negotiate the best price you can on each. Ask the dealers if they can hold them until you phone them back. Then rush round to the smart antique shops on Pimlico Road in Belgravia and Gray's Antique Market on Davies Street Mayfair, and offer your ten items to the dealers there.

They are used to "runners" offering them things they might be interested in, and are used to paying double the price asked at a street market, as long as they feel they can sell it for double again to their more well-heeled clientele. Of course, you will still have no cash to go back and buy the items you have managed to find buyers for, so you will have to act as a broker between Dealer A and Dealer B, taking a 20% commission from both on your first sale.

You can now afford to pay cash for the other finds you have managed to sell on to the swankier dealers, pocketing the whole profit for yourself.

Which biblical figure do you most admire?

I always grew up believing that Abraham was the epitome of a biblical hero. He was the fellow who was ready to sacrifice his son to demonstrate his belief in God.

Now, if I told you there was this chap who thought he heard God's voice in his head, chatting to him, asking him to stab his son as a sign of his religious devotion, you would want Social Services to have him sectioned and straight-jacketed immediately.

How do you sleep at night?

How do you sleep at night?

I sleep the untroubled sleep of the innocent. This involves a variety of medications ranging from Temazepam, Mogadon, Zimovane or Stilnoct, which I mix around so my poor brain doesn't develop immunity to anyone of these delightful capsule coshes.

People tell me they have depressing after-effects, leaving you groggy and grumpy the next day, but obviously I wouldn't notice.

Note: Last year my doctor broke the news to me that Temazepam was now to be classified as a Class A drug by the Home Office. He said the only way he could go on prescribing it would require me to become a registered drug addict. This didn't bother me particularly until he advised me that the Home Office is fabulously leaky and that my spiral-into-drugs-hell would be instantly placed with the Daily Mail.

Do any artists ever vocalize displeasure at the way you've hung their work? Does this deter you from showing their work again?

Not very often. Always.
There is no escaping my belief that I always know best when it comes to installing art, and behave like a sulky, and unforgiving diva if I don't feel wholly appreciated at all times.

Does anyone watch adverts on TV anymore? Doesn't everyone just Sky+ everything, and then fast-forward during the commercial breaks? Are advertisers too stupid to know this?

Either I've changed or the advertising industry has, but I simply loathe commercials interrupting programmes. Of course, when I was making commercials I always hated the silly way programmes kept interrupting our ads. But hand-on-heart I do think ads today are corny, the ad breaks are interminably longer and more frequent than they used to be, and the broadcasters raise the volume to awesome levels during advertisements to arrest your attention.

All very irritating and self-destructive because, as you point out, many people now have the technology to zip past the commercial breaks, and so of course they do. And if they don't, the commercial breaks are now so lengthy, they have time to create a 3-course meal rather than the traditional cup of tea.

The stupidity of advertisers and broadcasters who take the public a) for granted and b) for mugs is bewildering. Being greedy and short-sighted is one thing. But pretending the internet isn't around and taking over your world is another.

I read that Nigella is 49, but she is still very youthful looking, and in fact appears to never age. Can you tell us how she manages it?

Having observed Nigella closely for some time, I have three possible explanations:

Theory 1

Nigella is an alien from a distant galaxy, where she is 3 of their years old, and where life-expectancy is 200. After I fall asleep she transforms into her natural self, a very large pale green squid/crab with razor-sharp steel molars for crunching chicken bones by the hundred, downstairs every night in the kitchen.

Theory 2

Nigella was created in a black-ops CIA funded cloning experiment. She has two brains and is able to defeat the combined teams of University Challenge with ease. She is also able to consume vast quantities of foodstuffs, and simply remoulds herself regularly, back to a 26in waistline. Her existence was denied by the authorities when the Nigella Project was terminated, after the CIA could no longer afford to feed her.

Theory 3

I have no Theory 3.

CIA Headquarters, Langley, Virginia.
Possible birthplace of Nigella Lawson.

My daughter of 6 wants to know if I believe in God. I don't, but don't want to rupture her innocence. What would you say?

Innocence is overrated.

I have been told I am on a seven-month waiting list at my NHS hospital for a knee operation. It is very painful, but I can't afford to go private. Any advice?

Get rich or walk with a stick. Sorry, but our politicians have created exactly just that kind of caring society.

My husband is a hypochondriac, not in itself unforgivable, but he has now become a financial burden as our private doctors' bills are mounting exponentially. A cure please?

Divorce.

Do you now, or have you ever seen a psychiatrist?

Do you now, or have you ever seen a psychiatrist?

I have paid a visit to a psychotherapist, or perhaps he was a physiotherapist, but an ex-wife made me go in an effort to help me improve as a hubby. I walked into his house, he looked rather like Leo Sayer, and I could see his eyes light up. Looking around at his art collection of Hirsts, Emins and other popular favourites, I realized that perhaps he was looking forward to this session rather more than I was.

Anyway, not wanting to disappoint, I made up a twisted tale of increasing weirdness about my need to wear my mother's clothes at night, being too frightened to go inside a chemist shop, nightmares about squirrels etc. Eyes glistening, he lapped up every detail of my little problems and booked me in for multiple appointments. But I had bored myself at the end of session one, couldn't face another, and gave up the chase to make more of a fist of my life.

Leo Sayer, slightly less good-looking than the lookalike psychiatrist.

My new bank manager is driving me crazy, regularly phoning with threats to refuse to cover cheques for tiny sums unless there is enough cash in my account. He is aware my pay cheque comes in monthly, that I work in the civil service and have an excellent credit record with the bank. He is clearly trying to make a mark at the bank with this aggressive approach to people who are feeling financially stretched in the present climate. I know he is trying to make me commit to an overdraft facility, for which of course the bank will want to charge a handsome fee. How do I solve this irritating problem?

You write the following letter to the Chairman of the bank:

"I am a customer at your blah blah branch, and am concerned that the new manager who has been installed appears to be behaving most embarrassingly, telephoning me on regular occasions making inappropriate suggestions. He uses the pretext of wanting to discuss trifling details about my account, leaving me finding his attentions uncomfortable and disrespectful.

I have done nothing to encourage his approaches, and as a long-term customer of your branch,

in a responsible civil service post, and with an unblemished financial record at the bank, I felt it only fair to alert you, and ask for you to discreetly arrange for my account to be handled by another member of your team.

Thank you for your assistance."

Every banking big-wig I have ever met is a wet noodle and will panic at any hint of impropriety at his bank and resolve the issue immediately. The troublesome new manager will probably be dispatched to some dark outpost without a word, because nobody senior at the bank will want to be involved in the messy business of discussing the issue.

And of course in the unlikely event of the bank not swallowing your claim, you will have written nothing that could not be interpreted as a straightforward response to being harried for money.

Note: This observation about banks obviously does not include Coutts & Co, bankers to Her Majesty the Queen and I. We both agree they are perfectly lovely. (And they kindly sponsor my gallery.)

My parents took me to the Saatchi Gallery last month which I actually quite enjoyed, but the problem is they now think I am as interested in art as they are, and want to take me to art museums all the time. I don't want to hurt their feelings, but I really don't want to be dragged round galleries every weekend. As it's all your fault can you help me!

Listen young person, consider yourself fortunate that your parents are prepared to let you accompany them round their favourite museums. They are providing you with an important initiation for your future – an easy familiarity with the most fertile known environment for introducing yourself to fine new friends of the opposite gender (or the same gender if that's how things turn out). Be happy.

Are you in touch with your feminine side?

I fear I only have a feminine side.

You are meant to be tyrannical about installing the art in your exhibitions, and don't let artists interfere. Why?

There are very few people who know how to install art. David Sylvester was a master, and we talked of little else except how inept most artists are at showing their work to best advantage. Sadly, nearly all professional curators are equally caught short in this dept.

I may not be much good at most things, but if I didn't have the pleasure of planning and installing shows, and doing it better than anyone else, I would have stopped buying art many years ago.

Apologies if that sounds a shade immodest, but there it is.

David Sylvester, the great art writer and curator

Some of the art you buy looks like you need glasses? Have you had your eyes tested?

I used to wear contacts, but gave them up when I had one eye lasered. So now, I can see things at a distance adequately, and also read a newspaper without a problem. Maybe this technique has a flaw, which you have been kind enough to point out. But sorry, were you attempting to be witty?

Do you enjoy the theatre as much as you do the visual arts?

I find the theatre faintly embarrassing for the actors performing on stage. It seems rather showy-off in an undignified way. So although over the years I have seen dozens of plays that were entirely thrilling, mostly now, the moment the curtains open, I fall quickly asleep.

Of course, poor Nigella finds this in itself faintly embarrassing, particularly when the lead or the playwright is a friend. And as two of the people we're close to are the leading theatre producers Michael White and Robert Fox, you can see why she gets pretty cross when I do this at one of their premieres.

What car or cars do you own?

I have a 1995 black Lincoln Town Car, huge, comfy, with just the right amount of mafia don presence. I haven't driven it in years, but thought I might need it one day for an emergency trip to the local A&E if one of my strange children is broken in some way. Of course when the emergency came (it was raining and I was too lazy to walk the 100 yards to the newsagent) the battery was so shocked at being asked to start the car, it promptly died.

So my majestic Lincoln still sits there, unable to do anything much except gather dust and bird droppings.

What is the worst job you have done?

I was 20, working my way around America, and served in a shoe shop, Thom McAn in Los Angeles. It was unpleasant duty during a heatwave and I could only handle half a day.

Which newspapers do you read?

All of them. Well, not the Daily Sport, and not all of them very thoroughly, but I enjoy the different characters of each of our newspapers, by far the most robust in the world, and the varied slant each gives to its reporting. I marvel at their expertise at winkling out proper news, despite the drastically reduced budgets nowadays for investigative long-term story building.

I was once in the New York Hamptons mansion of a publishing tycoon, and it was one of those dinner parties where the host guides the conversation so that the table as a whole has to discuss a topic. As the visitor from Britain, I was asked to express my views on the US Press, which amounted to an unrestrained mad-dog attack on the New York Times, it's pomposity and overweening self-satisfaction, it's complacency built over years of being a lofty monopoly, easily illustrated by its arrogance in asking readers to "now turn to page B21" or wherever, to continue reading most of their stories.

My fellow guests looked at me curiously, even pityingly. They turned out to be the Editor, News Editor, Features Editor and Arts Editor of the New York Times, and it didn't take them long to show me how robust the US Press can be. When the Sensation / Giuliani controversy became a leading NY news story, I got given the steel-toe-cap kicking I obviously had coming.

China, India, America, Arabia – your gallery is on a bit of a world tour with its exhibitions isn't it?

What's wrong with that?

What is the worst thing anyone has said about you?

I don't believe anyone has ever had an unkind word to say about me.

Has anyone made art about smell? What's your favourite smell?

Some artist somewhere will have made a "smell" work of art, but I have so far missed it. My favourite smell is the ever-popular one of babies, which I can vouch for is lovely. Then, when they get about ten years older I remember the disappointment when I found they now carried the whiff of smelly underarms. And soon after you teach them about deodorants, they begin turning into delightful teenagers and treating you like a bad smell yourself.

You have been married three times. Are you an optimist or an idiot?

You have been married three times. Are you an optimist or an idiot?

Three times so far.
We all know the thing about second marriages being a triumph of hope over experience, but then once one makes a habit of getting married, it seems a bit rude to go out with anyone and not marry them.

Nigella finds it rather common to be my third wife, and would have found it more chic to be my fifth.

What is your guiltiest pleasure?

If it's a pleasure, where does guilt enter into it?

I don't think you've ever been featured on Desert Island Discs, but what would be your 10 favourite records you would take if you were stuck on a desert island?

I can't think of anything more irritating than being stuck on a desert island, and listening to the same 10 records over and over again isn't going to improve things much.

I read that you didn't agree with the rankings of the World's Top 200 Artists of the 20th Century that your gallery produced with The Times newspaper. Surely this was a democratic vote by over 1½ million of your website visitors and Times readers. So why would you presume to know better?

I remember saying that no two people on earth would agree on who the top 200 artists should be, let alone the order they are ranked.
Would you like it any other way?

Have you ever been convicted of a criminal offence?

No. But that doesn't mean I haven't deserved to be. One of my ex-wives gave as her grounds for divorce my "unreasonable behaviour". People get locked up for far less every day.

Who would you have at your ideal dinner party?

Nigella Lawson, Dominic Lawson, Nigel Lawson, Horatia Lawson. It appears I have a thing about the Lawsons.

How did you and your brother manage to start your agency Saatchi & Saatchi when you were in your twenties and get it to No.1 so fast?

It's hard to imagine how any client could entrust their advertising account to two pushy youths with silly names, carrying-on with a burning righteousness that would have fooled nobody.

Or so one would think. There is no answer or formula I can offer. We worked brutally hard, and got blindingly lucky.

Note: My brother did the client contact part, and we made sure he was so well briefed, so well versed, that whenever he attended a meeting with head people from prospective clients, he knew more about the client's problems and opportunities, and more about their competitor's prospects and weaknesses than any other person in the room.

Not much different to the Method School of Acting where you "become" the part you are playing, Stanislavski style. We adopted the Method approach so my brother could "become" a purposeful executive, vital and energetic, alert to new ways of improving your business model and build your brands, bursting with flair and optimism.

However laughable this must sound, for some reason it worked. Of course, it didn't hurt that my brother was well-endowed in the brains and charm dept, certainly more than I was.

Do you have a favourite designer whose clothes you wear regularly, or do you usually mix different designers around?

There is a certain kind of narcissist, the deeply self-satisfied kind, who feels any designer plumage would obstruct the view to their own innate gorgeousness. That would be my kind. I don't like clothes shopping, and trying on outfits in stuffy cubicles in men's shops, looking hideous in the wrap-round mirrors, is something I attempt as seldom as possible. So every few years I go to Selfridges and buy 10 identical black suits, 20 identical white shirts, 10 identical black shoes and never have to spare a thought about what to wear.

What music would you like played at your funeral?

I have asked to have no funeral, and no memorial service. I hate other people's and would certainly not appreciate my own.

Who is your favourite Bond Girl?

Samantha Bond.

Any dirty tricks I should watch out for when buying art from dealers?

Any dirty tricks I should watch out for when buying art from dealers?

The one that I have learnt, finally, to avoid is the charming little scam of selling you a work of sculpture without mentioning that it is one of a number of identical ones, an edition. Unlike a print, you often do not find an edition number e.g. 1/5, stamped on the sculpture. So you only discover what's going on after you see the sculpture that's sitting in your own home, also sitting in someone else's, or in a museum show.

I have been stung in this way by dealers high-powered enough to know better, and they always plead the same excuse – we assumed you knew.
Of course, there is no mention of the oversight on their invoice either.

My advice is always to be wary enough to get the exact details of what you are buying in writing, however high-end the dealer may be.

Jeff Koons and Damien Hirst – you discovered them both in their early days, but which one do you think is the greater artist?

They both have made so much extraordinary work that their position in the pantheon of greats is assured. That said, both of them have been rather off-form for a while, and would have done better to show far less from what we will kindly refer to as their mid-career period. But you can be absolutely certain both artists will break through again with something remarkable and unexpected.

Do you remember your dreams?

This is the kind of dream I would like to have:

I would have won my first Formula 1 Grand Prix at 18, my first Wimbledon title at 19, my first Oscar for Best Director at 20, edited The Sunday Times at 21, written the play, and book, of the year at 22, etc. Instead I usually dream of walking around in public places having forgotten trousers and underpants, desperately trying to tug my shirt down to hide my embarrassment, but nobody seeming to notice or care.

Apparently this dream is not uncommon, and means you are a wonderful, modest person of even temperament and great integrity.

You have stated your love of the movies. Who are your favourite Hollywood Leading Ladies?

Now that is what you call a question.
In no meaningful order whatsoever:

Rita Hayworth in Gilda
Grace Kelly in To Catch A Thief
Audrey Hepburn in Roman Holiday
Irene Dunne in The Awful Truth
Greta Garbo in Camille
Bette Davis in Jezebel
Marilyn Monroe in Some Like It Hot
Elizabeth Taylor in Cat On A Hot Tin Roof
Goldie Hawn in Overboard
Julianne Moore in Hannibal
Anne Baxter in All About Eve
Ginger Rogers in Top Hat
Jodie Foster in Silence Of The Lambs
Anne Bancroft in The Graduate
Ellen Barkin in The Big Easy
Jennifer Jason Leigh in Single White Female
Jane Fonda in Klute
Diane Keaton in Something's Gotta Give
Meg Ryan in Sleepless In Seattle
Ashley Judd in Double Jeopardy
Elaine May in A New Leaf
Deborah Kerr in The Grass Is Greener
Gena Rowlands in Gloria
Alicia Silverstone in Clueless

Demi Moore in Mortal Thoughts
Hilary Swank in Million Dollar Baby
Patricia Neal in Hud
Shelley Winters in Lolita
Frances McDormand in Fargo
Kathy Bates in Misery
Geena Davis in A League Of Their Own
Louise Fletcher in One Flew Over The Cuckoo's Nest
Ann Blyth in Mildred Pierce
Lana Turner in The Postman Always Rings Twice
Dakota Fanning in Man On Fire
Helen Hunt in As Good As It Gets
Lauren Bacall in Written On The Wind
Lucille Ball in The Long, Long Trailer
Kim Basinger in L.A. Confidential
Angelica Houston in Prizzi's Honor
Barbara Streisand in What's Up Doc?
Joan Allen in The Contender
Angela Lansbury in The Manchurian Candidate
Meryl Streep in Kramer vs Kramer
Joan Crawford in Mildred Pierce
Barbara Stanwyck in Double Indemnity
Carole Lombard in My Man Godfrey
Claudette Colbert in It Happened One Night
Doris Day in Pillow Talk
Eva Marie Saint in North By Northwest
Jayne Mansfield in The Girl Can't Help It
Michelle Pfeiffer in Scarface
Jean Simmons in The Big Country
Katherine Hepburn in The African Queen

Olivia de Havilland in The Heiress
Ingrid Bergman in Notorious
Angelina Jolie in The Changeling
Tippi Hedren in Marnie
Kim Novak in Vertigo
Joan Fontaine in Rebecca
Melanie Griffith in Working Girl
Janet Leigh in The Manchurian Candidate
Uma Thurman in Kill Bill
Dianne Wiest in Parenthood
Shelley Duvall in The Shining
Nicole Kidman in The Others
Sissy Spacek in Coal Miner's Daughter
Merle Oberon in Wuthering Heights
Glenn Close in Reversal Of Fortune
Celeste Holm in Gentleman's Agreement
Ellen Burstyn in Alice Doesn't Live Here Anymore
Cathy Moriarty in Raging Bull
Charlize Theron in Monster
Holly Hunter in Broadcast News
Judith Anderson in Rebecca
Connie Nielsen in Gladiator
Marisa Tomei in My Cousin Vinny
Cher in Mermaids
Greer Garson in Mrs. Miniver
Lee Remick in Anatomy Of A Murder
Maureen Stapleton in Interiors
Mira Sorvino in Mighty Aphrodite
Cloris Leachman in High Anxiety

Due to space restrictions, and my poor memory, I will have overlooked many great performances and happy hours gratefully glued to the screen, so apologies if I've left out your personal favourite.

Do you have an eye for interior design? Do you think you have good taste?

The trouble with good taste is that absolutely everybody thinks they have it. But don't you sometimes wonder who actually buys all those really horrible clothes and sofas you see in shop windows everywhere?

Note: All rich people seem to gravitate between two preferred decorative styles for their homes.

Route 1

The sleek marble and glass minimalist expanse associated with top-notch hotels, sometimes all black marble and furnishings, sometimes all white, occasionally a daring mix of both, and sometimes even, a riot of beige, appealing to a formative experience of opulence epitomized by a Penthouse or Presidential Suite.

It is the style favoured by many successful interior decorators, their efforts lovingly captured in all their coolth by issue after issue of Architectural Digest.

Route 2

The Louis Quinze model, also driven by the desire of the newly-rich to appear refined and elegant, so lots of gilt, ormolu, heavy silk drapes, extravagant pelmets, brocaded wallpaper, ornate cabinetwork, Aubusson rugs and rococo a-go-go.

Again, an early influence would have been the experience of a sumptuous five star hotel suite, simply reeking of all things cultivated and stately.

The decorator's brief is to come as close to Versailles as possible: all rather harmless really, and keeping many craftsmen and designers in gainful employment.

Louis XV

Do you read up on every artist that you buy? Which art publications do you rate?

When I was starting out, I actually read all the articles in 'Artforum', and other heavy-duty, very earnest magazines covering contemporary art. I ended up knowing more about the work of artists I liked, or even didn't, than the artists' own dealers. Nowadays, I just quickly flick through the pictures in the art mags, and certainly spend more time looking at The X Factor than I do reading art theory. So if you are one of those art critics who feels this confirms my taste is shallow, join the line.

When you first see a new piece of work, what is the very first thing that pulls you in?

If it doesn't look like something I have seen 100 times before. Or if it's visually very pleasing, or visually particularly repellent. The repellent ones repel you for the right reasons 99% of the time, but every now and then something that looks weird wins you around and turns out to be something special.

Your gallery has a very successful website – but what are your other favourite websites?

I found out today that I have a Twitter site, in which I Twitter my little thoughts and have 229 "followers". This is great news, and I would like to thank the person, or persons, doing the Twittering using my name. As I have never Twittered even once, wouldn't know how, I am delighted that others are prepared to undertake this task for me, helping me appear vibrant and fashionable. Though why anyone would want to post "rode a bus this morning. It was a number one hundred and forty eight" is mystifying, as is understanding why anyone sane would want to read, sorry follow, this.

Do you avoid art parties because 99% of the time people spout complete drivel and only turn up for the free drinks?

Do they? I had no idea.

What's less tragic in the search for a boyfriend/girlfriend – both reek of being a loser: going on a dating website or asking to be set up through friends?

What's less tragic in the search for a boyfriend/girlfriend – both reek of being a loser: going on a dating website or asking to be set up through friends?

Horatia, Nigella's sister, always had this perfume brand she wanted to launch – "Desperation" with the slogan "You Can Smell It". What's wrong with trying anything and everything that's available to secure an acceptable mate?

You will need to practice polite ways to end a blind date that's not working out, in a diplomatic, but speedy, fashion.

My pal Steve used to arrange 4 meetings a night every hour between 7 and 10, so that he didn't have time to be haunted by self-doubt if things went poorly. Even if he met someone nice, he didn't appear too needy, as he had to move on to the next rendezvous on the schedule.

He was resilient, and could handle disappointment well (girls pretending to be very ill 2 minutes after meeting him, girls pretending to receive an emergency call on their mobile before he's finished his first chat-up line). His view was, if you can handle the humiliation, you will meet some interesting people and hopefully someone to settle down happily with, and have many babies, just as he has.

If you could have an invisibility cloak for a day, where would you go and what would you do?

It's such a lovely idea, but I couldn't think of anything I wanted to do with my cloak. Sneak in on the Queen having breakfast and listen to her chat to Prince Phillip? I believe I can imagine that tête à tête pretty accurately without having to witness it. Sit invisibly in a corner of the Oval Office, and listen in on the great affairs of State? I think they probably did it better on The West Wing, and certainly more effectively.

Sorry to sound so jaded, but there's nothing I can think of to take real advantage of this invisibility option. But a time machine, that would be interesting, if you have any other new household appliances to offer.

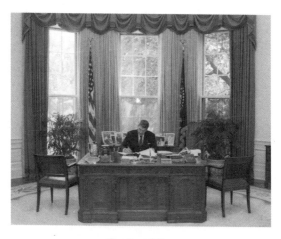

The Oval Office

I watched a Derren Brown programme where they had some advertising execs demonstrating how much advertising employs subliminal messages. Don't you think there is something horribly manipulative about this?

Everybody in advertising has heard talk of the "Golden Chalice of Subliminal Advertising". I can safely say I have never seen an example, though people tell me of tests in America in the 1950s where they flashed super quick images of an icy Coca Cola onto the screen, apparently invisible to the eye, and saw sales of Coke in the cinema triple immediately. Of course, it could be that they also turned off the air conditioning when the tests took place in Arizona in mid-summer, to help pull off this master-stroke.

Subliminal advertising is an urban myth, and nowhere near as much fun as a commercial that makes you laugh, or think. That's not to say I wouldn't much prefer subliminal versions of the endless Churchill, Go Compare, Confused.com commercials that air pitilessly.

Some of the ads I love the most all have great songs:
The Wrigley's gum ad – "Alright Now"
The Maltesers ad – "Dream Lover"
Lloyds Bank ad with the horse on the beach – "Layla" by Eric Clapton
How key is music in advertising?

Levi's invented the golden oldie backdrop for their TV commercials, courtesy of John Hegarty at his BBH ad agency. John had in fact previously introduced pop music as a background to a jeans commercial, working on another manufacturer for my agency in the early 1970s. He commissioned David Dundas to write something catchy, which turned out to be a little soft-rock number called 'Jeans On', that surprised everyone by going straight to the top of the charts.

Since then commercials featuring pop backgrounds have been a useful way to promote new releases, revive forgotten hits, resurrect forgotten recording stars, and as you point out, make the adverts memorable.

In more innocent times, most music in commercials used to be those fabulously awful jingles still swirling inside our heads for decades.

The contemporary art world is perceived as being very elitist and exclusive. What kind of an advertising campaign could you create in order to amend this conception so that it is more accessible to people?

The best advertising campaign would be a large museum filled with the latest contemporary art, some of which is controversial, all of which is interesting, centrally located in the Kings Road London, in a beautiful, airy building with vast and perfectly lit rooms, and allow the public in free of charge.

I am always scared of saying something stupid about a painting, that comes completely out of left-field and has not one iota of relevance to what the artist has intended or bears any reference in an art historical context. Do you have a clever-sounding one-liner that I could use?

"Very interesting use of perspective".
It applies to anything, believe me.

The Americans make brilliant drama series (The West Wing, The Wire, 24, The Sopranos, House, CSI etc...) – the UK equivalents, e.g. Life on Mars, Spooks, Holby City, Mistresses just seem so lame in comparison. Why can't we make anything as gritty? Is it our accents, the weather, our bad teeth?

And what about Dexter, Alias, Desperate Housewives, Prison Break, Criminal Minds, Medium, Life, Breaking Bad, Mentalist, Burn Notice? American TV series are not only better than the UK's, they're better than almost all American cinema these days.

But don't you think we've had some much better British drama recently, with State of Play, Rome, Bodies, Cranford, The Take? Of course, American TV can never reach the heights of University Challenge or Match of the Day, the week's favourites in our house.

Note: It's Gary Lineker's, Alan Hansen's and Mark Lawrenson's shirts on Match of the Day that make it so compelling, besides the occasional decent game. Every week they each produce their latest find, with delightful stripes, lovely piping and cuff details, and an exotic array of collar styles. That, and the punditry and commentary:

"Denied" as in "denied by the woodwork", a goal stopped by the goal posts.

"Clash"/"scrap" the top four premiership teams playing each other clash, the bottom four scrap.

"Attentions" a defender's efforts at hounding his opponent for the ball.

"Calling card" a player's delivery of a heavy challenge, flooring an opponent.

"Cauldron" a heated atmosphere.

"Cynical foul" when the player committing it doesn't even pretend it's an accident.

"Drought" no goals again, from a team with a run of poor results.

"Twelfth man" enthusiastic and supportive spectators.

"Screamer" a player "lets fly" with a powerful strike (sorry, kick).

"Fortress" a well-defended goal area, as in "they park the team bus" in the goal mouth.

"Ghost" a player who flits quietly around the opposition, unmarked.

"Hairdryer" a severe and noisy telling off at close range by the manager.

"Sitter" an easy goal chance, often missed/squandered.

"Handbags" a disagreement between players, where nobody is actually punched senseless.

"In their faces" a team that quickly and aggressively closes down any opposition move.

"Metatarsal" a part of the foot we are now all familiar with because it is regularly a victim of injury.

"Pub team" an amateur, lacklustre performance.

"Service" a neat and accurate pass from the midfield to the forwards.

"Silverware" are trophies.

"Talismanic" an inspiring player who can affect the outcome of a match.

"Tap up" an illegal approach to try and secure the services of another team's player.

"Big ask" when a minnow team need to beat Man U 4-0 to fend-off relegation.

"Torrid time" the lot of a player regularly made to look slow and clumsy by the forward he's trying to mark.

"Warming the bench" are players sitting on the sideline as potential substitutes.

"Aristocrats" are the ten biggest teams in European football.

"Anonymous" a player who has had a lacklustre game and made little impact.

"Clinical" a neatly executed goal.

"Group of death" when England are drawn into a qualifying shortlist that includes decent opposition.

Best of all, to the delight of Harry Enfield and Paul Whitehouse, those unmissable post-match player interviews with the incomprehensible Portuguese, Scottish or Croatian accents, and the managers with their distinctive facial tics, verbal dysfunctions and greasy comb-overs.

Have you had any homosexual experiences?

Have you had any homosexual experiences?

Sadly, I never went to public school, so I missed out on that one. But who knows, when I'm 80 I may enter a new lease of life in Tangiers.

I heard that you once wrote a film script. Is it true and what film was it?

In the late 1960s, David Puttnam and I worked together at the CDP ad agency. He left to start off as a photographers' agent and soon was representing many of the world's biggest names. He was obviously getting bored by his easy success, decided that he wanted to get into the movie business, rang to tell me he was very close to Simon & Garfunkel (giant global stars at the time), that they were desperate to feature in a film, but had so far rejected 16 scripts, and would I like to have a go at writing one. Having checked with him what a script actually was, never having seen one, I wrote something overnight, gave it to David who swooned with delight at its brilliance, showed it to Warner Bros, who were similarly enthused, and offered to send us both to New York, stay at the swanky Pierre, and present the script to S & G.

I pitched the script to small Paul [Simon] who promptly declared it was the first film he had been offered that he really liked, that Art [Garfunkel] would be back in town in a few days, we should hang about, have a nice time, come back and pitch it to him. Art Garfunkel's reaction to my pitch was quite hard to read as he seemed barely alive, zonked out on something or other. When I'd finished, Paul quickly jumped up and announced

"he loved it, just loved it".

David never heard from them again. This little setback didn't deter him for more than a moment, and soon he returned with a great new thought. "I've got this brilliant idea for a movie about gangsters, played by children, and I've even got a great title 'Bugsy Malone'. Will you write the script?" he asked. I had to say no to David, explained that I had decided to start an ad agency with my brother and didn't have any time, but did he remember the sweet lad in the office next to mine down the corridor at CDP, Alan Parker? He would make a lovely job of it, I assured him. Well, Alan and David made the movie, it was a big hit, Lord Puttnam went on to win Academy Awards and become one of the big Studio bosses, and Sir Alan went on to make many widely admired films in a glittering career.

Before you ask, I can't remember anything at all about my script, other than it was truly dismal.

Note: I did actually blow another chance to make it in Hollywood. Hard to believe, but at one time Saatchi & Saatchi was highly regarded in the City, and raised £350 million (a lot of money in those days – one of the largest ever UK rights issues, and to a company with little in the way of assets).
What made it particularly breathtaking was that the money was raised without an acquisition in place, something simply unheard of, and the cash was just there for us to look around for the right deal.

There were two contenders:
1) A giant US ad agency purchase that would take us to the top spot in the world league.
2) 20th Century Fox.
Both were about the same price, and like fools we went for the ad agency because we thought we know that business rather than the movie business, forgetting of course that in the movie business nobody knows anything.

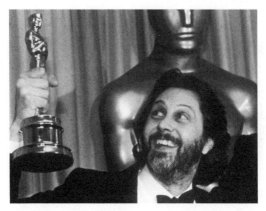

David Puttnam receiving his Oscar for Chariots of Fire

Did you learn anything useful at school? What was the highlight of your scholastic career?

I played First Witch in the school's performance of Macbeth, and still carry the cutting from the school magazine which declared "Saatchi illuminated the production". Other than that, Major Watterson taught us German and I still remember a little. "Alles in Ordnung" is about the extent of it. Before I got demoted to the 'C' stream, George Robb, outside right for Spurs, taught us history and even though I was a complete dunderhead, got me in to White Hart Lane to see a game. As far as school goes, I remember little else.

You seem to like art which is sexually provocative. Do you watch pornography?

I caught a few glimpses as a youth, thought it embarrassing for the participants, and found it off-putting rather than arousing. And I don't like art that is sexually provocative, unless it is great art.

Have you ever done manual work, or only ever worked behind a desk?

After I left school, I drove a grocer's delivery van around Willesden and Kilburn, and when you rely on tips you remember very fondly the ladies who gave generous gratuities, and can still point out their homes many years later. I also worked in a New York bar as a busboy during the evenings (clearing dirty dishes, cleaning down tables), and painting and decorating the bar during the day. No tips, but shared accommodation with other aimless young people like me, so every night fun-filled.

But you're of course right, I've never actually developed gnarled and horny hands formed by years of manual labour, which may in itself have been more satisfying, but really doesn't pay particularly well.

Why you?

?

Note: I assume you are asking why someone as indolent as me, as charmless, as self-absorbed, and with attitude issues, should have found any success at all? It's a fair enough question, which has clearly stumped me.

Hugh Grant or Colin Firth?

Both lovely.

Claudia Schiffer or Eva Herzigova?

Neither thanks.
I've never had a thing about models, or maybe I do have a thing, and the thing is I always assume they are as dull as tar, and have yet to be proved wrong. But do you believe that they would be even faintly interested in me?

Madonna or Beyonce?

Either.

Mercedes or Porsche? Ferrari or Lamborghini?

Taxi.

Daily Mail or The Guardian?

Both.

Frasier or Seinfeld?

Neither.

Gary Shandling is the only US comedy I have enjoyed since Sgt. Bilko and Rhoda. Nothing comes close to Extras, The Thick Of It, Outnumbered, Alan Partridge, Help, Harry Enfield, Getting On, Gavin & Stacey, The Office, Nighty Night etc etc.

Duran Duran or Spandau Ballet?

Both dreadful.

I read that you were a weak student at school, lucky to get a job at all. What advice would you give people who haven't had your lucky break? I know you're just going to say keep on trying, knock on many doors etc, but I am stuck in a menial job, and don't have time to go on endless interviews and keep my job and the wages coming in.

Keep on trying, knock on many doors etc.

Do you think advertising and art are linked in the pivotal role they give to sex?

Sex plays a pivotal role in many aspects of life, but personally I don't see anything particularly erotic about Monet's Haystacks or Ford's TV commercials.

I take your point of course, but I don't think art and ads are any more sex-obsessed than newspapers, TV, magazines, movies, men, women, teenagers, dogs...

Which advert are you proudest of?

A haemorrhoid treatment with the headline "How to lick your piles". An early work, that possibly never ran, but I think it illustrates my refined taste quite elegantly.

Do you send your children to posh schools?

One of our children's first school was so posh, that when a teacher asked the class "who is Mohammed?" a small boy stuck up his hand and quietly answered "our chauffeur".

If you could ask God for one wish, what would it be?

I'm the wrong person to ask. I would always assume God had his own agenda for suddenly offering to make my wish come true, and I don't really want to find out what that agenda might be. Sorry, I just don't see God as a genial Santa Claus type, with round rosy cheeks and twinkly eyes. Call me paranoid, even spineless if you insist, but that doesn't make me wrong.

Do you ever go to music concerts? Who was the last person you saw playing live?

I saw Stevie Wonder many years ago, before he became embarrassing, but even then he was well down the road to sentimental nonsense.

I did also go and see Sylvester perform in my Disco moment, but I'm too abashed to admit it.

A lot of the art world is often critical of you. What is it about you that puts people's backs up?

I don't know very many people in the art world, only socialize with the few I like, and have little time to gnaw my nails with anxiety about any criticism I hear about.

I remember our ad agency wasn't dearly loved by rivals, and we held that to be a symptom of our effectiveness. Rather like Millwall football fans, it made our staff burn even harder with the desire to squish all competition, and besides, our clients liked us quite a lot, and that mattered much more.

If I stop being on good behaviour for a moment, my dark little secret is that I don't actually believe many people in the art world have much feeling for art and simply cannot tell a good artist from a weak one, until the artist has enjoyed the validation of others – a received pronunciation.

For professional curators, selecting specific paintings for an exhibition is a daunting prospect, far too revealing a demonstration of their lack of what we in the trade call 'an eye'. They prefer to exhibit videos, and those incomprehensible post-conceptual installations and photo-text panels, for the approval of their equally insecure and myopic peers. This 'conceptualized' work has been regurgitated remorselessly since the 1960s, over and over and over again.

Few people in contemporary art demonstrate much curiosity, and spend their days blathering on, rather than trying to work out why one artist is more interesting than another, or why one picture works and another doesn't.

For example, I've heard that almost all the people crowding around the big art opening parties barely look at the work on display and are just there to socialize. Nothing wrong with that, except that none of them ever come back to really look at the art – but that they will tell everyone, and actually believe, that they have seen the exhibition. They don't know what they're missing, and I can truly say I'm not missing their approval all that much.

Note: Please don't read my self-serving views above as referring to the great majority of gallery shows, where dealers display art they hope someone will want to buy for their home, and new collectors are born every week. This aspect of the art world fills me with pleasure, whether I love all the art or not.

Further note: It's understandable that every time you make an artist happy by selecting their work, you create 100 new people that you've offended, the artists you didn't select.

I read that in your fifties you drove a go-kart for years. What was that about?

Mid-life crisis, are you enquiring?

Truth is, I have always been pretty hopeless at all sport, but tried a go-kart in one of those indoor playgrounds and found it fun. As I got used to the thing, and wanted to go faster, I discovered you could get karts with two engines and zip around quicker.

But one fateful day, someone told me about Racing Karts, used on outdoor tracks that really are very quick, and as I discovered, quite terrifying, screaming along a couple of inches off the ground, hitting 60mph in a very few seconds, and 90mph on long straights. The really quick ones could lap as fast as almost anything except a Formula 1 car, as they can corner really fast with their extraordinary grip.

Probably because I had finally found a sport that I could sit down in, I found it very pleasant, particularly as for some strange reason I was ok at it. It took a lot of practice, and a strict diet living practically on bird seed and a thermos of scrambled eggs, because weight is crucial, as it is with jockeys. My competitors were all in their late teens and twenties, but I was able to afford to spend much more than they on preparing my karts properly for each circuit, an expensive way of making up for any of my deficiencies by running through many engines and tyres to get the ideal set-up.

My rivals were all young and fearless, apparently

without the imagination of us older folk about spending our remaining years in a wheelchair or worse. They all wanted to make their mark and be noticed by the spotters from McLaren and Williams, looking, and finding, drivers like Lewis Hamilton and Jensen Button. Those two young boys were outstanding even then, and although nobody except mums and dads bothered to see the Juniors race, when these two were up everyone at the track stopped, and watched them wipe out the opposition, even when they were ten years old.

Anyway, here I was doing something sportif, loving the excitement of rushing into corners two abreast surrounded on all sides by other idiots like me, hurtling around inches apart. Terrifying to watch but exhilarating to participate in. And the worst injuries I got were some painful ribs, a couple of broken collar bones, and a glorious, bulging 14 inch haematoma on my calf when my brakes failed at the end of a straight.

So although I spent my entire youth as a person nobody wanted on their cricket or football teams at school, I had finally discovered a sport I could actually do well at, and ended up winning dozens of races and championships. I would never have given it up but for my daughter Phoebe hitting two, and becoming so adorable I couldn't bear to miss spending my weekends watching her grow and listen to her babble.

Besides, I never did get that call from Ron Dennis, boss of McLaren, offering me a spot on his Formula 1 team.

You play chess, poker, Scrabble. What are you best at?

My chess is laughable.
My poker is lamentable.
I can beat weaker players than me at Scrabble.

Note: I spent many hours learning all the bizarre 2 and 3 letter words in the Scrabble dictionary, pages of obscure anagrams, instantly wasted when they changed the dictionary to be used in championships. They've recently changed it again for the online version, so virtually any letter combination you can imagine now seems to be ok (he whimpered bitterly). Besides, the world champions all come from Thailand or Korea, can barely speak a word of English, but have committed the entire Chambers and Oxford Dictionaries to memory, and see the game as a mathematical challenge retrieving their built-in superchip listings.

Where do you find inner peace?

The lavatory.

If the new art you show in your gallery is so interesting, why don't others agree, and dislike your exhibitions?

The unperceptive are unreceptive. Or some other self-aggrandizing nonsense if you prefer.

The truth is that it would be a black day when everybody else likes the shows we produce, and I would finally know the game was up.

Do you believe that the majority of people would accept a cheque for £1 million, in exchange for 100 anonymous people dying in some Third World country?

Yes. But then I believe that most very overweight people would happily have 100lbs of fat taken away overnight in exchange for 100 anonymous lives being taken away somewhere far away.

However ghastly it sounds, I fear this is a realistic assessment of the human condition. Many people would sacrifice many lives as long as there was no impact to encroach on their well-being in any way.

So 100 dying in the next road along to your home might be hard to live with, but 1,000 lives lost somewhere on the other side of the earth, in exchange for making your own life much nicer… of course.

Am I too cynical? I don't believe so.

Do you like Sir Nicholas Serota, head of the Tate Gallery?

What's not to like?

If your gallery was burning down, what's the one thing you would save?

Me.

Do you feel that the glass is half-full or half-empty?

Do you feel that the glass is half-full or half-empty?

Either way, drink it and fill it up again.

What's it like working with the BBC on your programme looking for the next Art Idol?

The BBC is run by Ed Poll, who few outside the organization will know, but who rules with an iron rod, turns the most hardened veteran producer into mush, micro-manages every detail of every production to bring each firmly into line, has a messianic belief in the critical importance of his work, and brooks no argument.

Ed Poll is Editorial Policy, which at the BBC goes beyond political correctness, and assumes the mantle of an Orwellian watcher, peering over all shoulders at all times within the BBC, to make absolutely certain that the Corporation output is blemish-free and not compromised in any way.

But, as the BBC has allowed me to participate in the search for a new art star without having to put on make-up and actually appear on the show, I have enjoyed it. The truth is, I have been enormously grateful for the BBC my entire life, and without it Britain would have become a very barren place indeed.

Nature or nurture?

Do you mean what would happen to a 2 week old baby, mother a crack whore, father unknown, if it was adopted by a caring, wealthy couple from New York's Upper East Side, and grew up in a magnificent condo, went to top kindergartens and schools, and was offered a place at Harvard, Yale and M.I.T?

Or what would happen in a parallel universe when the wealthy New York couple forgot their baby at a diner while driving through rural Tennessee to admire the local toothless rednecks sitting out on their porches. The baby was seen as a gift from the Almighty by a fervently religious, but slightly retarded local woman, and grew up in her home in a run-down estate, where petty crime and brutality were an everyday occurrence. Little schooling, and working behind the counter in the local hardware store at 15. No offers from Harvard, Yale or M.I.T.

Now you may well be thinking that Environment is a greater influence on how life turns out, than Genetics. And that the crack baby ending up at Harvard proves the point. The well-heeled baby ending up selling claw hammers reinforces the point further.

I wish I could offer a satisfactory resolution to this verbose bit of whimsy, but as always, nobody knows anything much – certainly not about the interaction of genes and environment, or how their variables play out.

Answers on a Post-It please.

Is there a relationship between art and music? Has it influenced your own tastes in music?

Obviously art is influenced by everything, but the link between art and music has been clearly highlighted over the years.

For example, Free-form Jazz and Abstract Expressionism both grew alongside each other in post-war America. And the minimal music of Phillip Glass, Terry Riley, Steve Reich has obvious parallels with the art of Sol LeWitt, Carl Andre and Donald Judd being made simultaneously in the late 1960s.

As to the music I like, it would be quicker to tell you what I don't. I love my favourites of 50s and 60s R&R and Girl groups, Bubblegum, Heavy Metal, Blues, Standards, Cajun, Reggae, Rockabilly, R&B, Disco, Soul, Dance, Punk, Doo-Wop, Country, Arab and Indian music, even some Opera and Classical.

In short, I'll take Dr. Dre and Cyndi Lauper alongside Vivaldi and Stockhausen.

I don't like:

Brass Bands	Bagpipes
One-Man Bands	Marches
Big Bands	Most Jazz or Folk
Harps	Madrigals
Mandolins	Techno or Emo
Peruvian Pipes	Gospel or Funk
Irish Jigs	New Romantics
Church Organs	Europop

You spend hours apparently traipsing around all parts of London looking at galleries. Is it worth it?

Hardly ever.

It goes beyond curiosity into something of a medical condition to want to see as much art as I do.

Nevertheless, it is surprising how few people in the art world actually enjoy looking at art. Art critics mainly see the shows they are assigned to cover by their editors, and have limited interest in looking at much else. Art dealers very rarely see the exhibitions at other dealer's galleries, and art lovers seem to love being in the art world more than they love the art. I always wonder how much real pleasure they get from the actual looking aspect compared to the gossiping aspect.

The art world always seems to gravitate towards a consensus view about everything, passed along the art grapevine, with only a few of their number seeing the art they chatter about, or really knowing much about it.

Apologies if this sounds disobliging, but I have had a pretty close-up view of the art world for a very long time and it is no more noble a calling than advertising.

You were born in Iraq. Do you have any memories of it?

None.

I was three when my mother arrived in London, pregnant with my brother, spending 2 months getting to Britain safely, where my Dad had gone in advance to secure our visas.

When I got old enough to ask my Dad what Baghdad had been like, he described a lovely place, until the Arab countries decided to form an alliance with Nazi Germany, and some began to call in German specialists to help them build efficient concentration camps for Jews living in Arab lands.

Perhaps you can see how this would make Jews a bit nervy about the safety of Israel, and anxious about the inexorable growth of Islamic Fundamentalism.

Looking back to biblical times, to the Pharaohs in Egypt, the Pogroms in Russia, to Jew expulsions or worse throughout the history of mankind, you can see that Jews appear to have been a thorn in the side of almost everyone, always.

And today, whether the Jews had it coming or not, anti-Semitism has the support of both the liberal Left, and the moderate Right, and is now perfectly PC everywhere.

Recently I was sent a new book "Memories of Eden" by Violette Shamash on her family experience in Baghdad, and I was enchanted by

this memory her family had of my mother.

"An essay that my friend Daisy wrote at school well illustrates the situation. The subject was 'What do you cost your parents?' and this is what she wrote:

'Ever since I was born, I have been wearing my elder sister's hand-me-downs when she out-grew them. Now, she wears higher heels on her shoes, so when they wear down sufficiently they are just right for me. As I am eighteen months younger than her, I get all her school books when she has finished with them. I get her copybooks, too, and I carefully rub out everything she has written with an eraser so that I can have a clean exercise book to use at school. As my parents cannot afford the school fees, we are here at the community's cost.

If I am good, and look after my younger brother, my mother gives me one *fils* [about a farthing] to buy gargaree candy. My mother almost invariably cooks a soup for us so it is always easy to feed an unexpected guest by adding another glass of water, as she does for me, but my father is always served his meal before the gruel is thinned down. In summer we get a wood containerful of yoghurt, *'elba laban'*, every day. My mother adds a pinch of salt and a glass of water to it, then stirs it to a creamy mixture and offers the first glass of this to my father. She then adds another pinch of salt and another glass of water and my eldest brother gets the benefit of the second dilution, and so on down

the line. By the time my turn comes it is the colour of pallid milk and tastes more like salt water.

We all sleep in the same room, on a thin mattress that we put on the floor, and we roll up our coats and use them as pillows. And we still have room if a guest wants to spend the night. In summer, we sleep on the roof, and then we don't even need a mattress to sleep on, as we use the palm leaf mats that we make. This way we do not wear the mattress down too quickly, and anyway the mats are cooler to sleep on.

Unfortunately, I cannot tell you exactly how many *fils* my mother has given me so far, as I have not counted the number of times I have been able to look after my younger brother. You see, the work is not regular.'

In this way, a clever and cheeky schoolgirl described what poverty could mean, even though her family was not poor then by any means. She married, had four sons, and emigrated to England with her boys. Their name is Saatchi."

If you could swap places with anyone on the planet, who would it be?

If you could swap places with anyone on the planet, who would it be?

I once had a dog called Lulu, whom I adored, liked to play with, and took for runs every day before and after work, rain or shine.

I think being a dog with a very doting owner must be a really pleasant life.

So much nicer I'd imagine than being an oligarch billionaire, or a computer zillionaire, or a hero of the movie screens, or a rock god.

I'm too squeamish to be a brilliant doctor saving lives, too thick to add to the sum of human knowledge, too lazy to devote my time to being a golf or tennis or any other sport superstar.

So it's the canine life for me.

What is your best quality? What is your worst?

Who do you imagine cares?

Where do you go to be alone?

I don't. I prefer company other than my own.

What talent would you like to have had?

Flight.

What are your future plans?

Live long and prosper.

Sum up your life in 3 words

Blessed.

Who is the most interesting person you've ever met?

I've met many interesting people, but Nigella is probably as good as it gets.

Your favourite restaurant and why?

It used to be the Rib Room at the Carlton Tower, because we never saw anyone we knew there, and it was roomy and quiet enough to have a table for 6 and not have to shout.

Now, it's Scotts, because they have outside tables where I can smoke, the food is good, the staff charming. But best of all, is the parade of people going to Jo Hansford next door for their hairdos, and Louboutin next door to that with their customers tottering out in their new 6 inch heels.

Do you go huntin', shootin', fishin'?

I fished once when I was 9, failed to catch anything, but didn't want to look foolish going home empty handed so bought a cod from the fishmonger, and my mother was kind enough to pretend she didn't know that cod didn't swim in Highgate Pond.

How old do you feel children today should be before having sex?

Double standards here I'm afraid. Most parents of young teenage boys think it's absolutely ok if their sons can find girls who wish to be very liberated.

But with young teenage girls, parents tend to be more prim and fastidious, which of course doesn't stop girls today dressing like pole-dancers and putting pictures of themselves on the net looking as tarty as possible. Awful really, but preferable I suppose to having your boy doing the same.

What are your deepest regrets?

Je regrette tout.

When you were making TV commercials who were the film directors who influenced you?

I never directed commercials, just came up with the words or idea, so it would be faintly ridiculous to claim any influences from movie directors.

I always liked Hitchcock because he believed in telling a story straightforwardly, and I admired his particular gift for timing, for framing each shot, and his taste in icy blondes.

But there are many Hollywood directors who I am sure have influenced the way I look at everything (in no particular order whatsoever):

David Cronenberg *The Fly, Dead Ringers, A History Of Violence, Eastern Promises*

Hal Ashby *Harold and Maude, Being There*

Tex Avery/Chuck Jones *Daffy Duck, Bugs Bunny, Porky Pig, Droopy, Road Runner, Wile E. Coyote, Pepé le Pew*

Robert Benton *Kramer vs Kramer, The Late Show, Places In The Heart*

Robert Aldrich *Kiss Me Deadly, The Big Knife, Whatever Happened To Baby Jane, The Dirty Dozen, Ulzana's Raid, The Longest Yard*

J.J. Abrams *Mission Impossible 3, Star Trek [2009]*

Sydney Pollack *They Shoot Horses, Don't They?, Three Days Of The Condor, Tootsie, The Yakuza, Absence Of Malice*

Albert Brooks *Lost In America*

James L. Brooks *Broadcast News, Terms Of Endearment, As Good As It Gets*

Mike Nichols *Who's Afraid Of Virginia Woolf?, The Graduate, Heartburn, Working Girl, Postcards From The Edge, Charlie Wilson's War*

Victor Fleming *The Wizard Of Oz, Gone With The Wind*

Christopher Columbus *Mrs. Doubtfire, Only The Lonely, Harry Potter And The Philosopher's Stone, Harry Potter And The Chamber Of Secrets, Home Alone*

Michael Curtiz *The Adventures Of Robin Hood, Angels With Dirty Faces, Mildred Pierce, Casablanca*

Ron Howard *Night Shift, Parenthood, The Paper, Ransom, Cinderella Man*

Jonathan Demme *The Silence Of The Lambs, The Manchurian Candidate [2009], Married To The Mob, Something Wild , Melvin & Howard*

Michael Cimino *The Deer Hunter, Heaven's Gate*

Brian de Palma *Obsession, Carrie, Dressed To Kill, Scarface, The Untouchables, Snake Eyes*

Stanley Donen *Charade, The Grass Is Greener, Singing In The Rain*

Steven Spielberg *Duel, Jaws, Close Encounters Of The Third Kind, Raiders Of The Lost Ark, Jurassic Park, Schindler's List, Saving Private Ryan, Minority Report, Catch Me If You Can, Munich, Poltergeist*

Farrelly Brothers *There's Something About Mary, Dumb & Dumber, Shallow Hal*

Michael Mann *Manhunter, Heat, The Insider, Collateral*

Sergio Leone *Once Upon A Time In America*

David Fincher *Seven, Fight Club, Panic Room, The Game*

John Ford *Stagecoach, My Darling Clementine, She Wore A Yellow Ribbon, Rio Grande, The Searchers, The Man Who Shot Liberty Valance*

Alfred Hitchcock *Family Plot, Frenzy, Torn Curtain, Marnie, The Birds, Psycho, North By Northwest, Vertigo, To Catch A Thief, Rear Window, Dial M For Murder, Strangers On A Train, Rope, The Paradine Case, Notorious, Spellbound, Suspicion, Rebecca*

George Lucas *American Graffiti, Star Wars*

Mel Brooks *The Producers, Young Frankenstein, High Anxiety*

Elaine May *The Heartbreak Kid [1972], A New Leaf*

Robert Mulligan *To Kill A Mockingbird, The Stalking Moon*

Gary Trousdale & Kirk Wise *Beauty And The Beast*

James Cameron *Terminator 1 & 2*

Paul Verhoeven *RoboCop, Starship Troopers, Total Recall, Hollow Man*

Peter Bogdanovich *What's Up Doc?, The Last Picture Show, Paper Moon, Mask*

George Stevens *The Talk Of The Town, Woman Of The Year, Shane, Giant, A Place In The Sun*

William Wyler *Wuthering Heights, The Letter, The Little Foxes, Mrs. Miniver, The Heiress, Roman Holiday, Ben-Hur, The Collector, The Big Country, Detective Story, The Best Years Of Our Lives*

John Lasseter *Toy Story*

Frank Capra *It Happened One Night, It's A Wonderful Life*

Robert Altman *Mash, The Long Goodbye, The Player*

Roger Corman *Machine-Gun Kelly, The Fall Of The House Of Usher, The Pit And The Pendulum, The Raven, The Masque Of The Red Death*

Howard Hawks *Bringing Up Baby, Only Angels Have Wings, His Girl Friday, To Have And Have Not, The Big Sleep, Red River, I Was A Male War Bride, Rio Bravo*

Frances Ford Coppola *The Godfather 1 & 2, Apocalypse Now, The Conversation, The Rainmaker, Rumble Fish*

John Huston *The Maltese Falcon, Key Largo, Treasure Of The Sierra Madre, The Asphalt Jungle, The African Queen, Red Badge Of Courage, The List Of Adrian Messenger, The Man Who Would Be King, Prizzi's Honor, Fat City*

Elia Kazan *Gentleman's Agreement, A Streetcar Named Desire, Viva Zapata!, On The Waterfront, East Of Eden, Baby Doll*

Stanley Kramer *Inherit The Wind, It's A Mad Mad Mad Mad World, Judgement At Nuremberg, On The Beach*

Stanley Kubrick *Killer's Kiss, The Killing, Paths Of Glory, Spartacus, Lolita, Doctor Strangelove, 2001: A Space Odyssey, A Clockwork Orange, Barry Lyndon, The Shining, Full Metal Jacket, Eyes Wide Shut*

John Cassavetes *Gloria, The Killing Of A Chinese Bookie*

Andrew Stanton *Finding Nemo*

Ernst Lubitsch *Ninotchka, To Be Or Not To Be, Trouble In Paradise*

Orson Welles *Citizen Kane, The Magnificent Ambersons, The Stranger, The Lady From Shanghai, Touch Of Evil, The Trial, Macbeth, Chimes At Midnight, F For Fake*

Sidney Lumet *12 Angry Men, Fail-Safe, The Pawnbroker, The Hill, Serpico, Dog Day Afternoon, Prince Of The City, The Verdict, Before The Devil Knows You're Dead*

Clint Eastwood *Unforgiven, Million Dollar Baby, High Plains Drifter, The Outlaw Josey Wales, Play Misty For Me, The Eiger Sanction, The Changeling, Gran Torino, Pale Rider*

Dick Powell *The Enemy Below*

Joseph L. Mankiewicz *All About Eve, Julius Caesar, Guys And Dolls, Suddenly Last Summer, Cleopatra, A Letter To Three Wives*

Leo McCarey *The Awful Truth*

Tim Burton *Beetlejuice, Edward Scissorhands*

Lewis Milestone *All Quiet On The Western Front, Pork Chop Hill, Mutiny On The Bounty*

Billy Wilder *Double Indemnity, The Lost Weekend, Sunset Boulevard, Fedora, Ace In The Hole, Stalag 17, Sabrina, The Seven Year Itch, Witness For The Prosecution, Some Like It Hot, The Appartment, One Two Three, The Fortune Cookie*

Sam Peckinpah *The Wild Bunch, Straw Dogs, The Getaway, Bring Me The Head Of Alfredo Garcia, Ride The High Country, Major Dundee*

Coen Brothers *Blood Simple, Raising Arizona, Miller's Crossing, Fargo, No Country For Old Men, Barton Fink*

Arthur Penn *The Left-Handed Gun, The Miracle Worker, Bonnie And Clyde, The Chase, Little Big Man, Night Moves, The Missouri Breaks*

Roman Polanski *Repulsion, Rosemary's Baby, Chinatown, Frantic*

Charles Chaplin *City Lights, A Countess From Hong Kong, A King In New York, Monsieur Verdoux, The Great Dictator, Modern Times, Limelight*

Andrew Adamson & Vicky Jenson *Shrek*

Otto Preminger *Anatomy Of A Murder, Advise And Consent, Laura*

Hanna/Barbera *Tom & Jerry*

Sam Raimi *Dark Man, The Quick And The Dead, Drag Me To Hell*

Oliver Stone *Born On The 4th Of July, Salvador, W*

Martin Scorsese *Mean Streets, Alice Doesn't Live Here Anymore, Taxi Driver, New York New York, Raging Bull, King Of Comedy, GoodFellas, Cape Fear, Casino, Gangs Of New York, The Departed*

Fred Zinnemann *The Men, High Noon, From Here To Eternity, The Nun's Story, A Man For All Seasons, The Day Of The Jackal*

Don Seigel *Invasion Of The Body Snatchers, The Killers, Two Mules For Sister Sara, Dirty Harry, Charley Varrick, The Shootist, Escape From Alcatraz*

Douglas Sirk *Magnificent Obsession, All That Heaven Allows, Imitation Of Life, Written On The Wind*

Herbert Ross *The Owl And The Pussycat, The Goodbye Girl, The Seven-Per-Cent Solution, The Sunshine Boys*

John Frankenheimer *The Manchurian Candidate, The Train, Seven Days In May, Seconds, Black Sunday, French Connection 2, Ronin, All Fall Down*

Preston Sturges *The Lady Eve, Sullivan's Travels, Unfaithfully Yours*

Quentin Tarantino *Reservoir Dogs, Pulp Fiction, Jackie Brown, Kill Bill 1 & 2, Inglourious Basterds*

Raoul Walsh *The Roaring Twenties, They Died With Their Boots On, White Heat, Captain Horatio Hornblower*

Woody Allen *Manhattan, Annie Hall, Interiors, Crimes And Misdemeanors, Broadway Danny Rose, Hannah And Her Sisters, Stardust Memories, Mighty Aphrodite, Zelig, Radio Days*

Robert Wise *The Day The Earth Stood Still, Somebody Up There Likes Me, Run Silent Run Deep, The Sound Of Music, The Andromeda Strain, West Side Story*

Norman Jewison *Moonstruck, The Thomas Crown Affair, The Cincinnati Kid, In The Heat Of The Night, Agnes Of God*

Martin Brest *Midnight Run, Beverly Hills Cop*

John Landis *Into The Night, Trading Places, An American Werewolf In London, Animal House*

Errol Morris *The Thin Blue Line*

Jack Arnold *The Incredible Shrinking Man, It Came From Outer Space*

Robert Rodriguez *From Dusk Till Dawn, Sin City*

Alan Pakula *Klute, The Parallax View, All The President's Men, Presumed Innocent*

Rob Reiner *Spinal Tap, The Princess Bride, Misery, Postcards From The Edge, When Harry Met Sally, The Bucket List*

Curtis Hanson *The Hand That Rocks The Cradle, L.A. Confidential*

John Sturges *The Magnificent Seven, Bad Day At Black Rock, Gunfight At The O.K. Corral, The Great Escape, Ice Station Zebra, The Last Train From Gun Hill, The Law And Jake Wade*

Franklin J. Schaffner *Planet Of The Apes, Patton, Papillon, The Boys From Brazil, The Best Man*

Frank Darabont *The Shawshank Redemption, The Green Mile*

Alexander Mackendrick *The Sweet Smell Of Success*

Friz Freleng *Tweety & Sylvester*

David Lynch *Eraserhead, Dune, Blue Velvet, Wild At Heart*

Robert Zemeckis *Romancing The Stone, Back To The Future, Who Framed Roger Rabbit, Forrest Gump, What Lies Beneath, Death Becomes Her, Cast Away*

William Friedkin *The French Connection, The Exorcist, The Boys In The Band*

Taylor Hackford *An Officer And A Gentleman, Dolores Claiborne, Mortal Thoughts*

George Cukor *David Copperfield, Little Women, The Philadelphia Story, Gaslight, Adam's Rib, Born Yesterday, It Should Happen To You, Camille, A Star Is Born, My Fair Lady*

Martin Ritt *Hud, The Spy Who Came In From The Cold, Hombre*

George Roy Hill *The Sting, Butch Cassidy And The Sundance Kid, Slap Shot*

Ron Clements & John Musker *The Little Mermaid*

David Miller *Lonely Are The Brave*

Philip Kaufman *The Right Stuff*

Paul Thomas Anderson *There Will Be Blood*

Melvin Frank & Norman Panama *The Court Jester*

Carl Reiner *Enter Laughing, The Jerk, The Man With Two Brains, All Of Me*

Nora Ephron *Sleepless In Seattle*

Charles Laughton *Night Of The Hunter*

John Hughes *Planes, Trains & Automobiles, Uncle Buck*

Barry Levinson *Diner, Rain Man, Avalon*

Stuart Rosenberg *Cool Hand Luke*

Chris Noonan *Babe*

Ivan Reitman *Ghostbusters, Kindergarten Cop*

Bob Rafelson *Five Easy Pieces, The King Of Marvin Gardens*

Robert Rossen *The Hustler, All The King's Men*

Tony Gilroy *Michael Clayton*

Charles Vidor *Gilda*

Anthony Mann *Winchester '73, The Naked Spur, The Man From Laramie, The Tin Star*

Richard Fleischer *20,000 Leagues Under The Sea, The Vikings, Compulsion, Fantastic Voyage, Tora! Tora! Tora!, Soylent Green*

Edward Dmytryk *The Young Lions, The Caine Mutiny, Mirage*

Terence Mallick *Badlands, Days Of Heaven*

Phillip Noyce *Dead Calm, The Bone Collector*

Lawrence Kasdan *Body Heat, Silverado, The Accidental Tourist, Big Chill*

Steven Soderbergh *Out Of Sight, Sex Lies And Videotape, Erin Brockovich, Traffic*

David O. Russell *Three Kings*

Jim Abrahams & David Zucker *Airplane*

Henry Hathaway *True Grit*

Gary Fleder *Runaway Jury, Don't Say A Word, Kiss The Girls*

Stephen Sommers *The Mummy*

Bryan Singer *The Usual Suspects, X Men*

Robert Redford *Ordinary People, Lions For Lambs*

Gene Saks *Barefoot In The Park, The Odd Couple*

Rod Lurie *The Contender*

Frank Oz *Dirty Rotten Scoundrels, Little Shop of Horrors, Housesitter, The Score*

Paul Haggis *In The Valley Of Elah*

As you see, lots of holes and a confusing list of missing favourites, like John Boorman and Ridley Scott, Paul Greengrass and Tony Scott, who I claim for England rather than Hollywood. Likewise no David Lean, no Carol Reed, no Peter Yates, no John Schlesinger, no Robert Hamer, no Tony Richardson. (It all gets particularly illogical when I include, say, Alexander Mackendrick, the American director who made Sweet Smell Of Success for Hollywood, but not his great Ealing Studios films, The Ladykillers and The Man In The White Suit).

And obviously I have included nothing with subtitles, though even I can tell the mastery of Resnais, Bergman, Fassbinder, Pasolini, Kurosawa etc etc. I also don't know how some of these films would hold up now, but it's been fun trying to remember as many as I could. So thanks for this question, it seems to have awoken my synapses.

Your ad agency had a reputation of being very cocaine friendly. Are you a drugs user?

I had one puff of a marijuana roll-up many many years ago, and that's it. My agency on the other hand was referred to as White City, but although many of our people were very hyper, worked 20-hour days fuelled by something other than enthusiasm, queues of odd-looking people were making deliveries at all hours, and some of our execs' mood swings and paranoia were alarming, the clients seemed happy enough, the creative work was ok and occasionally brilliant, staff morale extraordinarily high, and the business just kept on growing and growing.

I didn't ever feel the need to take any moral high ground, but more importantly didn't want to appear wet and already prissy and past it before I hit 35.

Who would you like to portray you in a film of your life?

Nobody would want to see a film about me, including me.

Do artists deserve to get as rich as Damien Hirst, who I read is worth £100 million?

Only if you think of art as entertainment, in which case his pay-scale sits alongside Tiger Woods, Harrison Ford, Roger Federer, Johnny Depp, Madonna and the other superstars.

If you prefer to think of art as something more spiritual, and disapprove, can we agree that there is something very spiritual about Roger Federer's backhand?

Note: Art only flourished in the Renaissance because it was subsidized by the rich, and the Church. Even sacred art relied on patronage and successful artists who were in demand became wealthy. Perhaps even in those days people were more fascinated by how much art fetched, than the art itself.

Do you believe in the afterlife?

I know I don't like looking backwards, but this takes looking ahead a step too far. Anyway, in the next life I probably won't be as fortunate as I've been in this, so best to live for the present.

If you were on Death Row, what would you want for your last meal?

I believe I would be executed at 6am, so it should probably be breakfast.

Do you go to church?

I like cathedrals, and have seen many of the great ones in Europe.

Chartres is my favourite, and like its competitors in any listings of World's Great Places Of Worship, it does the job of inspiring shock and awe at the omnipotence of religion.

They are all equally powerful expressions of the humbleness of the individual in the presence of the Almighty, and one can see why religious belief has held such sway for so long, and inspired much hatred and war, as well as succour.

I'd be perfectly happy to convert to Catholicism if I could hold my next marriage ceremony at Chartres, but I gather they don't go in for divorcees, particularly serial ones.

Do you hang art in your toilet at home?

I once suspended a Marc Quinn life-size figure hanging upside down in a small, but tall, guest lavatory. It was a dark orangey rubber cast of his body, looking rather like a shed skin, dangling by its feet so that its head was alongside yours as you sat. I don't normally play silly games with art, but the artist was coming over for supper, and I thought he would appreciate my connoisseurship.

I read in your Wikipedia entry that you collected cigarette cards, jukeboxes and comic books when you were a boy. Was this the start of your obsession with collecting?

The joy of journalism is that once something is printed, all writers given the assignment of a 'profile' get their facts from previously published 'profiles'.

So someone somewhere must have written about my non-existent collection of cigarette cards and jukeboxes (I did once own one, but it kept breaking and I kicked it to death). These nuggets of fascinating facts have been repeated regularly enough for me to begin to sometimes believe they must be true.

I liked Superman comics in the 1950s, but for literary rather than acquisitive purposes.

I didn't develop my compulsive/obsessive disorder until I got lost in the labyrinths of the art world.

Do you want to be buried or cremated?

Why would I care?

Do you have a personalized number plate?

I barely have a car (see question on p.21).

What are you favourites of these cities?

London or New York?
Both lovely.

Rome or Paris?
Rome.

Berlin or Amsterdam?
Berlin.

Edinburgh or Glasgow?
The furthest north I've been is Hendon.

Vienna or St. Tropez?
Both creepy.

How do you feel about global warming?

It's obvious nonsense, but it makes nice people feel good about themselves to do their bit for the planet.

It's vanity of a grotesque kind to believe that mankind, and our "carbon footprint" has more impact on the future of earth than Nature, which bends our planet to its will, as it sees fit.

This would all be a harmless fad, except that it is now costing the West trillions of dollars to go "greener", with the blessing of caring souls and the Kyoto Protocol, while much of the world still lives in grinding poverty or simply starves to death.

Do you remember your first kiss?

I don't. My greatest fear is to meet ex-girlfriends from my teenage years, who are now tottering little old ladies, like me.

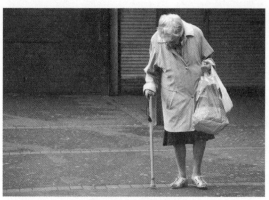

A previous girlfriend?

I don't like abstract paintings, and firmly believe that nobody would notice the difference if the Rothko paintings at the Tate were hung upside down. In fact, do abstract paintings carry "right way up" arrows on their backs to avoid this happening?

An amusing but pointless point.

Art isn't an IQ test. If an abstract painting looks as bad to you upside down as it would the right way up, it's apparent that neither view would give you much pleasure.

Paintings do have labels on their backs, and often signatures, useful clues to the gents installing the work.

Why not spare a little time to look into the era when Impressionism grew into early abstraction, and then onto the full-blown freedom that Pollock allowed himself, and see if this small introduction helps you to enjoy many of the key works of the 20th century.

Where is your favourite place in the world?

My bed, with its oversized plasma screen at one end, and Nigella babbling away at the other.

I would like to start a career as an artist. Any tips?

I hate to sound like a romantic adolescent, but I believe artists don't generally see art as a career choice, they simply can't overcome their desire to make art, and will live on little income for as long as they have to, before they start to sell their work – or give up and get a paying job.

The best introduction is obviously a good art school, so put together your portfolio, and unless you are comfortably off anyway, prepare to work nights to pay your fees.

There's a 10% chance you will end up with a "career", but in the meantime you should have fun, make friends and be inspired to make a go of something in the art world.

Were you bullied at school, or were you a bully?

I attended school as sparingly as possible, bunked-off most days, and bunked-in to the cinema with my other dissolute friends, or played cards or snooker. I neither had much opportunity to bully or be bullied, but remember a happy few days at school when I stayed longer than merely to answer the register.

How does it feel going from an advertising whizz-kid to a past-it pensioner?

How does it feel going from an advertising whizz-kid to a past-it pensioner?

There are some gratifying advantages to becoming elderly.

The first, naturally, is that you are still alive. And it is rather a blessing that eyesight weakens with age, so that your shaving mirror doesn't bear witness too sharply each day to your sorry deterioration.

There is also pleasure to be gained from other people's success, an emotion previously alien to me. Also, I can vouch for that truism about advancing age making a person more mellow. So I no longer find your question faintly rude, but rather refreshing in its directness.

You were very fat for a while, and then you went on a mad diet and got thin. Have you always been a yo-yo binge eater and dieter?

When you lose about 300lbs of unsightly weight, you can feel yourself turning into a Fat Nazi, finding tubby people unprepossessing and lacking in self-discipline and dignity.

Not me. I think that resembling a mobile barrel of lard is rather charming, and I wish that society, and the grim reaper, looked more kindly upon fatties, granting them the same amiable affection bestowed upon, say, gingers.

Were you any good at picking-up girls when you were young? What was your chat-up line?

In my late teenage, I tried many different approaches and personas, all pretty ineptly. During my "Bohemian" years I would wear black jeans, a black sweater, carry a well-thumbed paperback by Jung or Kafka, and try and look moody and deep. But I only met moody and deep girls so it made for somewhat dull evenings.

Another approach I adopted was to attempt a French accent, when believe it or not, the French were considered cool, and used it to some effect at discos frequented by attractive but dim girls who found my cosmopolitan-ness intriguing.

My highest rate of success was with lonely au pairs, on the basis that they were bored witless by their jobs, being stuck away from home in dull Britain, and were quite happy for any male company. Certainly not a track record to be proud of, or give me any credibility to offer up any useful advice.

Which living person do you most admire?

I like me quite a lot as you have possibly gathered.

But even then, I can't bring myself to do much actual admiring, because I know too many of my limitations and failings.

I would never admit that I greatly admire Nigella, because she probably suspects it already, and would become impossibly cocky if I confirmed openly that I am the girl in the relationship.

Is there a quick way to become pretty knowledgeable about contemporary art – a Dummies' Guide that could fast-track me?

Thank you for your lovely idea, which I certainly intend to steal. There is no such guide, and I think you've discovered that there is a real need for one.

But rather than my stealing it, why don't you produce it yourself, becoming an art expert at the same time, and hopefully find yourself with a bit of a bestseller?

All gallery shops across the world will be happy to stock it, including ours. Send me a copy if you remember.

What do you want on your gravestone?

I assume my ashes will be left in the incinerator. But if you wish to provide me with an inscribed headstone, I'd like:
May The Force Be With You.
Because You're Worth It. Amen.

What do you want your children to be?

People who do what they say they will do.

Will you be going to Heaven or Hell?

Both sound dreary. Any other options?

Duccio di Buoninsegna, Descent To Hell, 1308–11

Are you a racist?

Are you a racist?

Do I hate Black people, do you mean? It's hard to say, because I'm a bit colour blind about race.

So although my three favourite actors are Denzel Washington, Morgan Freeman and Will Smith, and I grew up thinking that Fats Domino, Chuck Berry and Berry Gordy were the most wonderful people on Earth, there are lots of things about some Black people that I don't like.

But then I can truly say the same about Iraqi Jews. Or the French. Or the Upper Class. Middle Class. Lower Class. Or Dentists. Or Plumbers. Or Conservatives, Socialists, Liberals. And certainly all Greens.

People always say sex sells, but what if you are plump and plain – surely you can't hope to buy into the projected glamour of say the Dolce & Gabbana perfume ad with the two beautiful models in the boat?

You're right of course. But Messrs Dolce & Gabbana probably wouldn't want somebody plump and plain sitting on the boat in their ad.

Their mistake. That picture would certainly stand out, get much favourable publicity – and even if it didn't shift much perfume, it would be a breakthrough that would enhance the brand, making it appear edgy and right-on.

I'd like to know, how do you untangle the wires behind the TV?

Nobody could untangle the wires behind my TV, or even find them, behind the stacks of dusty books, magazines, abandoned DVD players, old shoe boxes, defunct amplifiers etc.

How the TV system works at all is just God being nice to me, as always.

If you could have lived through one artistic movement in time (i.e. Surrealism, Impressionism...) which era would it be?

The YBA's.

Is there any work of art you own that you would admit is a bit "Emperor's New Clothes"?

It can all be "Emperor's New Clothes", if you want it to be. But it's probably more interesting to be open to contemporary art, rather than simply seeing it all as a conspiracy by smug and self-satisfied arty types.

If you respond to new music, new theatre, new films, you might give new art another chance to ensnare you, by finding a few artists whose work you find captivating, and going on from there.

I'm about to move out of my flat because of an extremely noisy neighbour. I want to do some evil act as a parting shot for the misery he's inflicted over the last months, but don't want to get my landlady (a relative) into trouble. Any ideas?

Find your nice landlady her next tenant. Advertise the flat in NME and MOJO Magazine, seeking a trombonist, bagpipe player or drummer.

Offer the flat to the most self-absorbed and driven of the applicants, and encourage them to practise away, day and night, until they make it on Britain's Got Talent.

If he could also be very fond of cooking smelly curries every day, and his love-making is very frequent and high-volume...

An Ideal Tenant

What's your idea of a hellish evening?

Standing around at a cocktail party, taxi waiting to take me on to the next cocktail party, and then two more cocktail parties after that.

I know some people enjoy this lifestyle, and I'm aware that it's my loss being such a dud, but it's a little late for me to enroll in Socializing For Beginners classes.

Who would win in a draw off between you and Nigella?

I can't draw at all, but compared to Nigella, I am Michelangelo.

I sing better than her. And she simply can't play Scrabble. Other than that, she can beat me at everything, and doesn't keep this a secret from our children or friends.

On your deathbed, what would you choose as the last work of art you ever lay eyes on?

I'd like to be watching Match of the Day's Goal Of The Month.

I prefer books to paintings, which infuriates my boyfriend who likes going around galleries. We argue endlessly about the merits and power of each of our passions. Can you help us decide whether words are more important than pictures in influencing people?

Many people get more enjoyment from reading, than from art. After frittering away my best years writing advertising copy, I obviously believe in the power of words and imagery – and it's easy to demonstrate. Faced with just the names of well-known celebrities, people conjure up vivid, wildly varying "pictures" of each person.

If I say "Bono" for example, many of you will see a titan of modern music, a wonderful showman whose performances fill the heart, a beacon of goodness, using his fame to promote charity and conscience.

Others would say "Bono" is a dull singer of corny songs, whose acclaim is mystifying, and whose "charedy" work is a crutch to inflate his own sense of self-importance.

We form strong opinions about people we have never met, but seen and heard a great deal about through words and pictures that have shaped and influenced us.

Another example, "Paris Hilton" some would find sparkly and fresh, her immense charm resting

in her ability to hide her light behind a dotty, air-head persona, even though her IQ is probably in the high 160s.

Others would say "Paris Hilton" is rather plain, quite stupid and utterly talentless – another of those bizarre people who have emerged in the last decade who are famous for their famousness.

My point here is that some people are swayed by pictures, some people are persuaded by words: it is the structure of our brain cells which determines whether we prefer one over the other, or both equally.

Or neither – some people just like country walks.

How do you feel about the S&M and Bondage aspects of sex?

Eek! Sounds painful, so I'm not really a suitable candidate for treatment, I'm afraid.

I did once ask room service at the hotel I was living in after a divorce to send out for two large bags of cat litter. My girlfriend who had come round needed them for the cat back at her flat. But the young concierge who delivered them up to the hotel room couldn't hide his blushes, and I can't think what he assumed we might need the cat litter for. His imagination was clearly more colourful than mine, so I must be a bit of a dullard in that dept.

Have you ever stolen?

I believe the statute of limitations has expired on any admission that I pilfered from my mum's purse when I was 10. I did it three times, and felt so sickened with guilt after each heist, I promised Santa Claus that I would henceforth go straight.

What is your favourite book?

The Count Of Monte Cristo by Alexandre Dumas. It's the opus of choice for all Revenge nerds.

Do you like visiting artists' studios?

If I like the art, it's very pleasant. If I don't, it's very disagreeable. It's much worse for the artist, of course, particularly when I'm uncertain, and just dithering, and finding it difficult to produce a fake orgasm.

Do you keep a diary?

No. And I have little short-term, medium-term or long-term memory.

So you'll be glad to know an autobiography is out of the question.

How long do you spend on the phone each day?

I have had an ear removed and a Nokia attached in its place to maximize telephonic efficiency.

Is there anything hanging in your house by your own hand?

I have nailed up some pictures all by myself, yes.

Do you believe in abortion?

Do you believe in abortion?

There are a number of people I have come across whom I feel would have benefited from this drastic, but understandable in the circumstances, precaution.

Would you rather live in Buckingham Palace, the White House or the Vatican?

If I could knock out most of the interior walls and floors, and create a large, airy, nicely-located museum, I would happily occupy any, as caretaker.

I'm sure no other duties would be expected of me, and I am prepared to do a house-swap with any of the current incumbents.

What is your height? You display the cravings for over-achievement associated with short men.

I'm neither 7ft, nor 5ft. So rather ordinary in stature really. But many thanks for your kind psychological profiling.

What's the best thing about Britain?

It isn't France.

And although London is far from perfection, I love it.

Can you change a plug?

Anyone can change a plug. I am living proof.

Michael Frayn or Harold Pinter?

Simon Gray and Tom Stoppard are my favourite modern playwrights, and I prefer to read the plays rather than see them performed. I cannot read Michael Frayn or Harold Pinter.

Were you ever a Marxist or a Lefty?

Between 16 and 18, when I was especially half-witted. But doesn't everybody hold soppy Socialist views as part of the teenage process which for obvious reasons, slowly evaporate as you grow up?

That's me behind the Lenin poster.

Don and Mera Rubell

Victor Pinchuk

Heiner Bastian

Frank Cohen

Peter Ludwig

Count Panza di Biumo

Steve Cohen

Karlheinz Essl

Eli and Edythe Broad

David Geffen

Si Newhouse

Leonard Lauder

How do you get on with the other big art collectors?

In my early days there were only about ten big collectors around the world, and we all knew each other well enough to know what we were each buying, and our different approaches. The two biggest ones were Peter Ludwig, a chocolate magnate from Germany, where he has left many museums to the nation, with the Ludwig Museum in Cologne being one of the world's nicest. He specialized in buying one key example by virtually every big-name artist. Count Panza di Biumo from Italy took the alternative route of buying a few conceptual and minimal artists, but each one in great depth, often commissioning site-specific installations. He started collecting when he liked the look of little black and white reproductions of Franz Kline works in American art magazines and started buying those and Rauschenbergs when they were both unknown young artists.

In Britain today my favourite collectors are Anita and Poju Zabludowicz in London and Frank and Cheryl Cohen in Manchester. Both of them have opened their own gallery/museums and are very adventurous, much more so than I, about the art they show. I like Noam and Geraldine Gottesman who are generous supporters of the Tate and have a beautiful collection of Hockney, Bacon, Freud, Auerbach etc. I've also met Andrew Lloyd Webber,

who seems amiable enough, and fortunately for me collects art very different to the works I chase after.

I find Don and Mera Rubell from Miami enchanting. They open their collection to the public and produce better shows than you'll see almost anywhere in America. I find Victor Pinchuk very easy to like and he too has opened his own museum in the Ukraine, introducing his country to the joys of Damien Hirst.

I know François Pinault very little but admire his collection very much, and his efforts to make Venice a permanent beacon for contemporary art. I enjoyed working with Heiner Bastian at the Hamburger Bahnhof Museum in Berlin on 'Sensation', where he has spent twenty years or more putting together the unrivalled Marx Collection which concentrates on the work of Twombly, Beuys, Warhol and Rauschenberg.

A nice chap called Karlheinz Essl from Austria came to say hello when he was in my gallery, and I didn't know much about him, but quickly discovered he was a much bigger and more important collector than me, with his own museum in Vienna.

David Geffen, besides his other successes, is clever and funny and probably has the best collection in America. Eli and Edythe Broad are the saviours of Los Angeles museums with their philanthropy and gifts of top-notch artworks. Si Newhouse, owner of Condé Nast, probably has

the best eye in America and specializes in buying a perfect piece by each artist he likes. Ronald Lauder has opened the Neue Galerie in New York, a breathtaking museum of German art, and brother Leonard Lauder has probably been the greatest benefactor to America's Whitney Museum. I loved Phillip Johnson, one of my favourite architects, who left MOMA many contemporary masterpieces.

I like Lew and Susan Manilow, who with Stefan Edlis, have helped regenerate the Museum of Contemporary Art in Chicago. I got to know Steve Cohen, currently America's biggest collector, quite well and considering he is so sincerely rich, he's rather self-effacing and nice company.

I find that generally big collectors can laugh at themselves more easily, and are much less pretentious than most other inhabitants of the art world. And of course now there are dozens of them all around the world.

What was the secret of your ad agency's success?

We always believed in having an enormous lobby. I remember when we started out our lobby was bigger than our offices, but we had such few staff it didn't matter. We used to hire people off the street to man the typewriters and click away busily whenever a prospective client walked through, creating an atmosphere that was thrusting and vibrant. Embarrassing to admit this ridiculousness, but it was so long ago...

How much do you give to charity each year?

£100 billion. Does that make me a nicer person, please Sir?

Do you ever cycle to work?

I have cycled, and for days at a time when I was 10. I haven't got on a bike since, but am quite efficient at knocking cyclists over whenever I drive my car, which thankfully for them is seldom.

Do you prefer the company of men, or women?

I am totally bisexual in everything but sex.

Your favourite holiday?

Before I discovered the endless joys of Italy, I used to time my holidays for Wimbledon fortnight, and saw so much tennis that nowadays I can only rouse myself to see the great players at work. I have been to the South of France (vile) and the Croatian coast for our honeymoon (wet, windy, and moving very swiftly into cheesy tat, without the slow build up of, say, St. Tropez, which took 40 years to grow from charming fishing village to WAG hellhole).

Can I mention how lovely London is in August? This is my second year to have the city empty out, and be reinvigorated by trains of tourists walking about in black burkhas clutching black Amex cards, plus the delightful flood of visitors from the Far East, which continues to provide us with the traditional groups of smiling photographers, snapping away at Buckingham Palace, or pigeons, and fulfilling every cliché.

Selfridges or Harrods?

Love Selfridges. Hate Harrods.

Bus or tube?

I'd rather hitch.

Football or cricket?

Both. Not rugby, ever.

North Korea or Iran?

Many of the people who live there are probably rather nice, but their governments are unspeakable, and I suppose they did get voted in. Or did they?

Arnold Schwarzenegger or Sylvester Stallone?

Yes, please.

What are your personal feelings about the current situation within the advertising industry as a result of the digital revolution? Is the industry optimizing digital growth potential?

Search me.

Do you pray?

I don't. Do you think it might help?

Frank Sinatra or Ella Fitzgerald?

A little of each goes a long way.

Elvis Presley or Cliff Richard?

Are you joking?

Prince Charles or Prince William?

Prince.

Can you name all the people who have played James Bond? Snow White's seven dwarves? And the four houses of Hogwarts?

Yes I can.

How hands-on are you as a parent?

Although I grew up in the security of a loving family it never occurred to my parents, and others of their generation, to try and find ways to keep the children amused and entertained at all times – organizing sleep-overs, tickets for the cinema and theatre, and presents being handed over on a weekly basis.

My parents didn't seem to notice or care if the children were bored, and I remember many hours just spent staring out of the window at rain. Boredom was central to our lives as children.

Today's parents feel so guilty about spending too little time with their offspring, or not sticking by all the Principles of Perfect Parenting, we have created children who have been pandered to, catered for, to the point where their futures must hold much disappointment.

Instead of gifts at Christmas and Birthdays, weekly presents remove the excitement of anticipation, or the sense of receiving a real treat. Treats are now two-a-penny.

Instead of Children's Hour on the BBC to look forward to, there are now Multiple Channels, DVDs, Facebook, MySpace, iPods, 3G Mobile Phones, Theme Parks, Summer Camps, Winter Camps, etc etc.

Have I spoilt my children to unsustainable levels of satisfaction? Guilty on all charges m'lud.

Do you believe in the death penalty?

No problem whatsoever.

I also believe in the American 3-strikes-and-you're-out rule.

I don't like the misery that criminals inflict on the innocent, and I really don't care if I sound like Vlad the Impaler or a Sunday Express columnist – I want many more, much bigger prisons, to keep horrible people out of circulation.

Those furious groups of deranged, baying people you see on the news, banging on the doors of a police van delivering some child murderer to court – I'm on their side.

Note: I'm familiar with all the cogent arguments put forward by the anti-state-murder devotees. But if it's lives you want to save, there are countless numbers around the world living in squalor and disease who are more deserving of your help, and dying in their hundreds every day.

What are you most ashamed of?

What are you most ashamed of?

Many, many humiliations left me crestfallen, but thankfully have been forgotten. This particular one seems to haunt me still.

I was 17, arrived home a little drunk, and a little desperate, and our au pair's bedroom was down the hall.

She was a very blonde Scandinavian, but truly, madly obese, and her B.O. would startle a horse.

As I possibly mentioned, I was a teeny bit desperate, knocked on her door, and she was delightfully welcoming, as I made a fumbling attempt at a clinch.

The smell was overpowering even in my fevered state, and her body was perhaps a little too spectacularly fulsome, but I suggested that a bath together might be romantic. She looked puzzled but readily agreed.

Sorry to reveal that I passed out in the bath, and the incident was never to be discussed again.

But we both knew what an utter twerp I was. Helga, if you see this, I'm so sorry.

Why is your gallery always full of noisy school groups ruining things for everyone else?

It's free, so state schools can put us on their arts curriculum. We like to encourage school groups, because it's more fun for students than most school visits, and they leave thinking contemporary art is daft, or funny, or clever, or rude – but hopefully interesting enough to want to see more.

I'm sorry if you find exuberant school groups distracting – and of course I'm spoilt by being able to see the gallery empty out-of-hours whenever I like.

But I admit to getting gooey watching young visitors sat sketching away around a particular work they respond to – even if it's a Chapman Brothers sculpture that's particularly indelicate.

I suppose we could duct-tape shut the mouths of all visitors under 17, or ask for a heavy security presence to follow school children around, and remove any chirpy ones…

Would you buy art if there was no money in it for you?

Would you buy art if there was no money in it for you?

There is no money in it for me.

Any profit I make selling art goes back into buying more art. Nice for me, because I can go on finding lots of new work to show off.

Nice for those in the art world who view this approach as testimony to my venality, shallowness, malevolence, etc etc. Everybody wins.

How do you stop professional artists entering your children's art competition, passing themselves off as 15 year olds? With a prize of £25,000 it's too tempting don't you think, and they could always get a son or daughter or nephew to pick up the prize and fool you all.

The artworks are entered by schools on their students' behalf.

Also, I think they would spot it if one of their pupils suddenly produced a precocious masterpiece.

Do you like politicians?

I like Nigel Lawson.

In general the MPs I like are "conviction" politicians. So even someone like George Galloway, leader of Respect, commands attention because he is prepared to stand firmly behind his point of view, however disingenuous the approach, however crackpot the cause, however suspect his motivation.

I obviously feel drawn to politicians who hold forthright views, and are man enough to fight for them – even if their name isn't Winston Churchill, but Margaret Thatcher, Golda Meir, Angela Merkel.

The usual breed who are hungry for power seem to feel it's best to say little of consequence, and can barely land a good blow on a bereft incumbent, relying instead on voters' inertia. The great ally of dozy, third-rate oppositions-in-waiting is the ennui of a jaded public who think "It's Time For A Change".

What do you like most in women – beauty, brains, wit or character?

I've never been fussy. And I respond appreciatively to women who are even less picky than me.

How many times have you tried to give up smoking?

Never given it a thought, he wheezed.

Which historical figure has influenced you more – Machiavelli or Florence Nightingale?

I appear to have embraced the compassion and gentle heart of Machiavelli, and the ruthless cunning of Florence Nightingale.

The Lady With The Lamp

Niccolò Machiavelli

Would you rather own Picasso's Les Demoiselles d'Avignon or Pollock's Number One, both in New York's Museum of Modern Art?

Fortunately, I'm just not that acquisitive about art. So I would only be prepared to chew off one of my hands, for either.

Is hell other people?

Specifically in the art world, do you mean?

Is it better to give than to receive?

I don't enjoy either much.

I dislike opening presents, with the bestower eager to see a rhapsodic, and heartfelt, reaction.

I dislike giving presents, because of the burden you place upon the recipient to appear gushing, and sincere, in receipt of something sincerely undesirable.

Will you be buying up all the artists' work in your TV show, and selling it for great profit in several years time?

No. But if you think that's an easy way to make money, why don't you buy it all?

What would you say to accusers who claim your TV programme is going to be just X Factor for the art world?

I pray they're right.

What were your ambitions when you started out?

I very much wanted to learn to walk.

Which famous celebrities do you have on your speed dial?

On my what?

Do you live to work, or work to live?

I live to live.

Given the growth of biennales, international art fairs and forums, travelling exhibitions and itinerant artists – do you think art speaks a universal language or sometimes gets lost in translation?

Lsto ni rantslatoin.

Berlusconi or Brown at the helm?

I cannot understand why everybody doesn't emigrate to Italy in order to have Mr. Berlusconi running things.

It's a beautiful country, they play a nice game of football, and Silvio seems to like having a good time.

He probably goes to bed happier each night than Gordon Brown, as I suspect do most Italians.

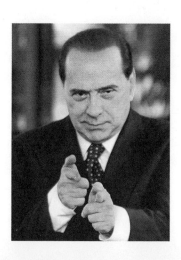

Better to serve in Heaven or reign in Hell?

Reigning in Hell sounds perfect.
Who in Hell would rather serve in Heaven?

What is the most memorable prank someone played on you?

After my first wife Doris and I started dating, she sent me a theatre ticket anonymously, from an "admirer". Knowing I wouldn't be able to resist such a tempting advance, blonde Doris turned up wearing a brunette wig, and looking rather alluring this mysterious and exotic creature worked her way along the row to the seat next to mine.

As she drew closer, her pleasure at seeing my face slowly turn from delight to horror at the full extent of my embarrassment, almost made the humiliation worthwhile.

What makes for a successful marriage? Is it an inspirational or aspirational idea?

I'm flattered to be asked, as my current wife is my third, and according to her, unlikely to be my last; I think you'd get a more professional answer elsewhere.

What was your worst excuse ever for dumping someone? And the real reason for doing so?

I never got the chance to dump anyone – I was always the dumpee.

I suppose the advantage is that you never have to be guilty about hurting someone's feelings, in itself a blessing.

Throughout history, art patronage has supported artistic development – the Medici, and the Church during the Italian Renaissance, the royal families and aristocracy of Europe, China, Japan, the 'renaissance' that we are seeing funded by oil wealth in the Gulf. How important is the role of patronage to the development of art?

You seem to know more about this than I do.

How have you managed to successfully negotiate the work/life balance? Are there lessons you've learnt on your life's journey?

Only work at something that doesn't feel like work. The journey is one way. No returns.

In your opinion, what sort of climate fosters brilliant artists?

Warm sunny days in Tahiti and the Côte d'Azur seemed to suit Gauguin, Matisse and Picasso.

What factors lead to a rich life?

Some people can have a rich life living in a small hut in Wales, writing poetry and illustrating children's books.

I think most people, however, believe a rich life entails money, and lots of it.

What personality trait would you credit for helping you to get where you are today?

Humbleness, and devoting my life to World Peace.

You have been credited with introducing American contemporary art to the British public as well as for making a generation of artists – Damien Hirst, Tracey Emin, the Chapman brothers – rich and famous. Have you always trusted your gut instinct?

I don't trust my gut instinct. It's just sheer vanity that makes me think I know what I'm doing.

What attracted you to the art world and what keeps you interested?

I'm not interested in the art world. I'm interested in art.

What artists from history do you admire and why?

I admire all artists. It's the cruellest job you could take on, particularly if you are gifted, but forever unrecognized.

What inspired you to get involved in art?

When you are 16 and trying to pick-up interesting girls hanging round galleries, now and again you see something interesting hanging round the gallery walls.

What advice do you have for those inspired by your TV series and really considering trying to make a living from art?

Don't try to become an artist. The odds are stacked very heavily against making a living out of it. But there are lots of ways to find fulfilling and decently-paid work in the art world, making art in your spare time – until the day Larry Gagosian, world's most powerful dealer, pops in with his eyes misting over with joy when he sees your work, and he tells you you are the next Jeff Koons.

Why should the viewer respect the views of yourself and the panel of judges in deciding who Britain's next great artists might be?

They shouldn't. I seldom respect the views of self-promoting glib art experts and trust that viewers of the show will treat us with the same disdain.

Many people find contemporary art confusing, self-indulgent, and provocative for the sake of it. What's your response?

It is confusing.
It is self-indulgent. And no question some of it is provocative for the sake of it. But new art seems to have survived since stone age artists drew graffiti on cave walls.

All art that looks cosy and familiar now would have been thought confusing, self-indulgent and provocative once. Even Turner, or Vermeer, or Michelangelo.

That of course, doesn't mean that at least 90% of contemporary art isn't fairly hopeless.

Note: This cave painting of a bison attacking a man, found in Lascaux, France, was seen by Picasso, who said "we have learned nothing".

What skills and qualities are you looking for in a "great artist"?

I don't know.
That's why I enjoy looking.

Isn't your TV show rather contrived – surely great artists evolve over time, as opposed to being thrust into the limelight through the medium of TV?

I'm touched by your romantic notion of the art world. Artists who are household names have sometimes barely left art school before being thrust into the limelight – top dealer shows, inclusion in museum surveys, championed by respected art critics, all by the time they're 25. Artists today can become international stars very early in their careers, without a TV camera anywhere in sight.

Which clients did you respect most at your ad agency?

Procter & Gamble, manufacturers of Pampers, Head & Shoulders, Duracell, Oil of Olay, Max Factor, Tampax, Braun, Gillette, Crest, Fairy Liquid, Ariel, Tide, Mr. Clean, Vicks, Clairol, Pantene, Flash, Ivory, Lenor, Oral B, Bold, Daz, Pringles, Wella, Herbal Essences, etc etc, is the most fearsomely efficient consumer goods marketer in the world.

P&G don't want advertising that anyone with creative ambition likes to work on; they rely on a well-tested, fairly straightforward and strictly adhered-to bible for agencies to fashion their ads, and P&G spend freely to make their simple and direct messages lodge in the memories of consumers.

Gallaher were the smartest of the tobacco companies, and their advertising for Benson & Hedges and Silk Cut made them a client every creative person in the agency dreamed of working on. Writers knew that the client was pushing the agency to break boundaries, rare in the advertising business, where it is generally the other way about.

When Lord King took over British Airways, it was a fairly instant turnaround of a dismal product to its favourite airline status. Sadly this culture at B.A. is long gone and the airline isn't having an easy time these days.

I have a soft spot amongst the mega-clients

for Mars, manufacturers of global brands like, Snickers, Bounty, Galaxy, Wrigley, Tunes, Minstrels, Maltesers, Milky Way, M&M's, Twix, Uncle Ben's Rice, Dolmio, and pet foods including Whiskas, Pedigree Chum, Sheba and Pal. They are the largest privately-owned business in the world, shared wholly between the Mars Brothers, John and Forrest Jnr, and their sister Jacqueline. Their business headquarters is a low-slung nondescript two storey building in McLean, Virginia where the Mars Brothers sit in a large open-plan office with well-worn brown wooden desks, amongst the identical ones of the rest of their staff. They live in two modest suburban houses. John and Forrest Jnr are conservatively worth $15 billion each. When they visited my brother's home in the country, they greatly admired the pretty house set in acres of picturesque rolling hills. My brother suggested that both of them could easily own better houses than this all over the world if they wanted, and with hardly a dent in their bank balances. They looked most surprised, and reminded him that they both had no actual money, they were merely managers of the business, in preparation for the next generation. Of course when Forrest Jnr wanted a divorce from his long-term wife Virginia, he was somehow able to write a personal cheque for hundreds of millions as settlement.

The Mars Brothers may be different to you and I, but they are much, much brighter and run

an organization almost on a par with Procter & Gamble. If P&G/Mars ever merge, they would make excellent rulers of the planet, and everyone would be very clean and nicely fed, including all pets.

Is it true that you dressed up as a cleaner, so that you could avoid meeting a client?

No. There was no dressing up. I was a touch shy in the early days about meeting clients, and did once use my hanky to clean the handrails, head down giving them a thorough polish, to shrink from a client walking through.

I regret it obviously, because when that little tidbit of gossip circulated, my reputation as being somewhat creepy, possibly certifiable, became fixed solid.

Happily people quickly accepted that I was a back-room boy best kept far away from clients, which suited me just fine.

I don't imagine you like pictures of beautiful country scenes by Constable and the other great landscape painters?

One of my favourite artists Boucher said about Nature that it's "Too green and badly lit".

Has your heart ever been broken?

It hasn't even had a bypass.

What was an important memory from your childhood that sustains you now, and that you would pass on to your children?

In the 1960s the road from London to Brighton was largely dual carriageway – with no speed limit.

It was something of an initiation in my brainless circle of late teens to drive from Trafalgar Square to Brighton Pier in under an hour. We would 'borrow' a parents' car, and get it to its top speed as often as possible throughout the journey.

One day, I borrowed a racing Mini from a pal who worked in a garage tuning racecars. It was stupidly fast and handled well, and the memory that sustains me is finding myself hitting 110mph on the Brighton Road, with a police car alongside, with the officers giving me a cheery thumbs up. They apparently were looking for what used to be termed a 'burn-up' with their Jag.

Happy to oblige, I was locked in an epic duel for about 8 miles, and found them quite hard to shake off. Much happy waving and horn-tooting when we slowed, and they peeled away.

My advice to my children when they get old enough to drive, is to wait until a police car draws alongside, and give it a try.

My daughter wants to go into advertising. She is doing a maths degree at Manchester University. Apparently many of her generation want to go into advertising, so any advice you can offer to give her a leg up?

Yes. Don't give up until you have got a place at a Top 20 agency in London or New York.

Start off by finding out about each specialist department within an agency, because they each need differing skills, and personalities. Choose the bits that sound right for you and apply for a graduate traineeship. If you can't get one of those, take anything that will get you inside.

Did I mention, don't give up until you have got a place at a Top 20 Agency?

It's a lovely life full of entertaining people and a thrill-a-minute atmosphere. And if you're good, the pay is high even while you're young enough to spend it madly.

Most students' idea of life in advertising

Do you realise that if you had kept your original collection together you would be worth literally billions of dollars?

Do you realise that if you had kept your original collection together you would be worth literally billions of dollars?

Probably you're right. However, I've had more pleasure showing-off new work relentlessly for 25 years, rather than hoarding everything away in a secure warehouse, cackling with self-satisfaction as I stroke all my treasures.

I assure you that many of the super-rich people I have met do not always have cheery, fulfilled lives.

Would you prefer your children to go into the advertising business or the art world?

I'm intrigued that you refer to advertising as a 'business' and art as a 'world'. Maybe I'm too close, but I can't detect much difference between the two fields, and both have the same number of bumptious charlatans and gentle aesthetes.

Our children are blithely indifferent to what I do for a living, or ever did. But then, none of them seem inclined towards food writing or being a TV cook.

Children today don't seem to talk in terms of growing-up to be train drivers or nurses, as earlier generations may have. How much nicer to be a child now, believing that you will be indulged and gratified throughout your hedonistic life.

In mitigation for my poor parenting skills and my inability to be a convincing role model, or lay any guidelines for our children's futures, I offer:

a) The fact that they are aware of my catalogue of failure at school.

b) That the only jobs I was fit for, or could land, were menial ones.

c) That it was only through sheer flukery I made a go of things at all.

d) Nigella is much brighter, so they can get better guidance from her.

Their logic is flawless, particularly as the cornerstone of their argument is that if I can make it, they certainly can.

Do you believe in Market Research?

I have spent too long being able to manipulate the answers I want from market research, to rely upon its findings any more than I do weather forecasts. Many of the great success stories in marketing only came about because someone at the top of an organisation wanted to ignore the research, and follow his own prejudices – on the basis that all his competitors would be carrying out the same research, receive back the same conclusions, follow them slavishly – and he would therefore be left with a unique proposition for his own product, which he in any event believed in.

We once bought a large US research company, whose specialist area was working for seven of the eight big Hollywood studios, pre-testing their films. The gentleman running this business was considered an all-powerful guru amongst the movie community, and his company would screen your movie at a preview stage, and have the audience score it before leaving the theatre. They would tick a) enjoyed thoroughly b) quite entertained c) rather bored etc etc and also a) would see again b) would recommend c) would advise against etc etc.

They would get ratings for each actor, and often try out different endings, to see which performances could be cut, and which finale worked more favourably. The studios could then determine which movies would be worth supporting heavily

with a big marketing budget, and which to quietly give up on.

I thought it would be illuminating to meet our guru running this company, and find out a little about how all the testing works. The thrust of my question to him was – if all of the studios produce twenty movies a year but only three of these make substantial profits, five of them do ok, and the others are financial flops, what useful guidelines did his research provide? Three out of twenty hits didn't appear to be a glittering track record for the benefits of pre-testing.

He explained one thing very clearly. 'Each Multiplex has screens allocated to each studio. The screens need filling. Studios have to create product to fill their screen, and the amount of good product is limited. So you have to go on creating films even if there is only mild enthusiasm for the project, in order to protect your Multiplex screen allocation moving over to a competitor Studio'.

It would be indiscreet for me to pass on other revelations he gave me about the dismal strike rate Hollywood achieves. But at least I now knew the answer to a question that had often puzzled me – how did that film ever get made?

Do you ever wish somebody dead?

Very seldom, surprisingly.
And never in a slowly-roasted-on-a-spit kind of death.

If you're offering, I'm sure I could provide you with names of a couple of people whose assassination wouldn't cloud my day. But nobody in the worlds of advertising or art I am happy to report.

How many works of art are you offered by dealers every day?

On a good day about 80.
On a better day about 8.

What's the best way to catch up with the art that's showing at galleries across Europe for a long, between-jobs, holiday I'm planning? I will be going to Holland, Italy, Germany, Poland, Sweden, Denmark and finally Russia. I'm sure I can find the obvious prominent museums and leading galleries, but what about the more unconventional galleries that specialise in experimental and groundbreaking art?

Visit the best art college in each city and ask the students about their favourite galleries.

Ask an art dealer you respect in London or New York who the best galleries are in each town on your tour.

Look on the internet for international art dealers who participate in the Basel Art Fair, Frieze Art Fair, Cologne Art Fair, the Art Fairs in New York, Miami, Madrid, Paris etc.

Ring up the editorial office of Flash Art +39 2 668 6150, & Artforum +1 212 475 4000 and send their correspondent or critic in each country an e-mail asking for advice.

I'm getting exhausted just thinking about all the hours you're going to spend wandering about galleries on your so-called holiday.

Is it true that the Myra Hindley painting was seriously damaged by attackers during 'Sensation' at the Royal Academy? Does it no longer exist?

I received a very agitated phone call from the Royal Academy on a Friday morning, during the 'Sensation' exhibition.

Terrible news they said – the Myra Hindley portrait, a 13 foot high painting based on her police mug-shot, created using the handprints of children, had been vandalised.

Apparently, a pair of protestors had hurled paint, ink and eggs at the picture, and the Royal Academy had three leading painting restorers examining it as I arrived.

Restoration expert No.1 gave me the bad news that the 'the ink and egg had fused with the surface of the picture and had become one with the painting' – utterly beyond repair.

Restoration expert No. 2 reassured me that given a team of four, and six months working with Q-tips, the picture could be restored by 60-70%, but some shadow residue would persist.

Restoration expert No.3 explained about a new technique developed in Japan involving high levels of microwave, that had proved effective on stubborn stains. It was very costly and time consuming, as each square inch of the canvas had to be microwaved individually.

It fell to me to phone the artist Marcus Harvey, break the news, and ask which of these options he preferred, if any. He asked me to deliver the painting to his studio, and he would see if it was possible to

Friday September 19 1997

The Mirror

30

EXHIBITED BY THE ROYAL ACADEMY IN THE SO-CALLED NAME OF ART

DEFACED BY THE PEOPLE IN THE NAME OF COMMON DECENCY

MYRA PORTRAIT WRECKED: SEE PAGE 7

THAT'S OUR GIRL: New star DJ Zoe

ZOE
I'm the one for Radio 1
SEE PAGES 12 & 13

PERIGO

MISSION: Help fulfil princess's wishes

DIANA
Join Mirror landmine campaign
SEE PAGES 4 & 5

work on it. It was with him by midday.

He rang me early the following Monday morning, and told me the painting was ready to be collected. He had worked on it over the weekend he explained.

How does it look I asked?

Perfect he said. Better than before, because it took so long to paint, it had gathered dust while it was damp. Now it looks clean and sharp.

What did you do I asked?

Lay it on the floor, covered it in Ajax and scrubbed it with a scrubbing brush, he replied.

The picture did indeed look perfect, and was back installed in its room at the Royal Academy that afternoon, but now with its own personal bodyguard.

The point here is that a professional restorer would never, ever, simply scrub a painting with household cleanser. He would have more respect for the artist, and the artwork to contemplate something so foolhardy and callous.

Only an artist could treat his own work with such nonchalant brutality.

What was it like finding yourself and your 'Sensation' exhibition in the New York Brooklyn Museum, become the main story on the TV news and newspapers for several days?

Someone told NY Mayor Rudy Giuliani there was a painting of a black woman posing as the Holy Mother, and covered by the artist with elephant dung. What's more, this picture was hanging in his city, in the Brooklyn Museum, which he funded.

Apparently many ferociously powerful religious groups were enraged, and wanted the painting removed, or the show closed, or the Brooklyn Museum to lose its funding, or even better, all three.

The show became a grenade, presented as a battle between a mad-dog mayor and a groundswell of supporters for the museum from freedom-of-speech activists. The painting's allies wanted to point out that there was nothing wrong with a black artist wanting to paint a black Madonna, and that the elephant dung was merely being used as blocks to support the bottom of the painting off the floor.

The problem for me was that I admire Giuliani, so when the assaults on the museum weren't hitting the right buttons, I didn't enjoy it when his troops switched fire to me, as a pornographer – with previous. 'A history of displaying depraved

and sickening works by weirdo so-called artists, for the delectation of superior art snobs'.

The museum was brave, won the day, the rolling news moved on, the show broke attendance records.

Looking back, it seems 'Sensation' in London drew its loudest protests about the Myra Hindley portrait.

In New York, it was clearly the Black Madonna. This picture attracted little controversy in London and, though it was clearly not 'covered in elephant dung', it was covered in many detailed close-ups clipped from Horny Housewives, which thankfully visitors were quite blasé about.

In Berlin, not a murmur, just happy crowds.

In Australia, show cancelled, when the Australian religious right picked up on the uproar amongst their counterparts in America.

Obviously I'm pleased the exhibition helped establish some of Britain's new artists as household names. And as always, I slither away, the Scheming Svengali wretchedly conjuring all the hoopla in advance, to serve my own perverse ends.

Why do your and other art museums play musical chairs with the same favoured artists? It's always Jeff Koons or Cindy Sherman or Elizabeth Peyton, Glenn Brown or John Currin or Cecily Brown at your gallery, or at the Serpentine, or the Tate, or the Whitechapel. There are other artists around, you know.

Have you come to the wrong shop, Sir?

Yes, I plead guilty to having shown all these artists, many years ago. And I admit that I included Luc Tuymans and Marlene Dumas in a 'Triumph of Painting' survey, even though the Tate had shown them both earlier.

I can see that it's frustrating that the artists who are most widely admired and influential get given wide exposure, and other important artists are rarely seen.

But may I plead my case for a moment? Since opening the new gallery in Kings Road our policy has been to only show very new art, mostly by artists who will never have been seen in the UK, and often seen nowhere except small local galleries around the world.

I think they call this a 'Mission Statement' nowadays – so if I let you down in the future you are entitled to come round and give me a mission statement of your own, to remember you by.

I can't get an interview at a top art dealer I want to work for, because all they say is they are not hiring at the moment. What would you advise?

Don't work for an art dealer.
It will take you forever to get any real money or power. Work for a top auction house, become an expert on something, develop relationships with the big buyers and sellers, start your own business, hire art dealers to work for you.

Do you still get the same buzz out of mounting shows as you did when you started out?

I do.

Do you have colours you dislike that you find put you off a painting?

Not really. But paintings with skulls, or children's dolls, put me off. Celebrity faces are only ok if your name is Warhol. Scribbled words are only ok if your name is Twombly. Harlequins are only ok if your name is Picasso.

Were you caned at school and why?

I was slippered several times with an old tennis shoe that looked about a size 14. I don't remember why, but I clearly couldn't have deserved it.

It did sting quite a lot, and the teachers were mean-spirited enough to check your trousers to see that you hadn't stuffed some notebooks or comics down there to protect your precious bottom.

It sounds somewhat barbaric looking back, indeed a bit pervy, to have masters getting young boys to bend over, and be lashed with a cane or shoe.

But those are the days we look back to as a gentler, more civilised, Britain.

Have you ever shaken hands with a member of the Royal Family?

I started to write No, but thankfully remembered I had.

A wife and I were invited to dinner by Prince Charles (no gilt invitation, his office rang), and I thought it might be entertaining, just the four of us at Windsor Castle. Or perhaps, they would have another couple over as well?

The line to shake our host's hand stretched back 50 yards, and of course I was ready to bolt for it, but like a starstruck fool, hung on.

He seemed pleased to be introduced, and I soon

learned why I had made it onto the invitation list. 'I have a small collection of my watercolours that I spent the Summer on, just through there, do let me know what you think.'

I started looking at the watercolours in a magnificent large room at 7.30pm, with 380 of his other close friends. Nobody was allowed into the grand dining hall until 8.30pm, so we all had plenty of time to admire each delightful sketch. At the allotted hour, we stood at our designated placements waiting for Prince Charles to be seated, before anyone else could be. A small choir sang a charming musical tribute to the Royal Family.

I discovered that I was seated next to Geri Halliwell. I can't be doing with 1990s Britpop, so I had no idea at the time who she was, but found her quick, funny and bright, and if you like gingers, not bad looking at all. The table was so wide the people opposite were hard to see, let alone talk to, but on my other side was a delightful lady with a diamond

Watercolour Study of Windsor Castle North Facade

on her ring the size of a decent conker.

The food was memorable. Tiny fragments of nouvelle cuisine, everything tastefully decorated with crossed chives.

I obviously stopped at McDonalds, Wandsworth on the way home.

What do you say to your critics who say you have shoddy taste in art, simply promote artists who are second-rate, buying them on the cheap, and turning them into valuable commodities you can cash in on? Furthermore, they would argue that your so-called 'discoveries', the Damien Hirsts, the Jenny Savilles, the Ron Muecks etc would have found success just as well without you buying up their art. Critics also think that your influence on younger artists is damaging, and encourages the view that it is more important to produce visually striking work, and achieve overnight success, than to carefully hone their technical skills, and be able to produce a professional standard in painting and sculpture. How do you respond to these points?

Thank you for sharing.

Author's acknowledgements:
Thank you to members of the public, journalists and art critics for
their questions.

All reasonable efforts have been made to contact and credit the copyright holders for
pictures used in this publication, if there are any inadvertent omissions, these can be
corrected in future reprints: © Evan Agostini/Getty Images for The Metropolitan Opera:
122 (Si Newhouse); © AP/Press Association Images: 57, 112, 122 (David Geffen); ©
Matt Baron/BEI/Rex Features: 37; © Raphael Borja: 127; © The Eli and Edythe Broad
Foundation: 22 (Eli and Edythe Broad); © Chryscampos.com, 2007: 99; © Susan K.
Donley, 2006: 82; © EPA/Davide Giulio Caglio: 143; © Sammlung Essl Privatstiftung, 2008,
Foto: Julia Stix, Wien: 122 (Karlheinz Essl); © Gottfried Helnwein: 122 (Peter Ludwig); ©
Gunter W Kienitz/Rex Features: 61; © Lisa Larsen/Time Life Pictures/Getty Images: 37;
© Paul Laster 2004: 122 (Don and Mera Rubell); © Greg Mathieson/Rex Features: 10; © Patrick
McMullan: 122 (Steve Cohen); © The Mirror, 19th September 1997: 165; © The Mortensen
Collection of Robert Balcomb: 140; © New York Daily News, 27th September 1999: 169;
© Lesley Olver: 173; © Terry O'Neill/Hulton Archive/Getty Images: 61; © Press Association
Images: 75; © Lotte Prechner/Penguin Books: 105; © The Print Collector/Alamy: 140; © Rex
Features: 37 (Barbara Stanwyck); Courtesy Ronald Reagan Library: 46; © Joe Schildhorn/
Patrick McMullan: 122 (Leonard Lauder); © Photograph by Snowdon/Camera Press London:
19; © Steve Sant and World of Stock, 2009: 45; © Eitan Tal: 54; © Denise Truscello/Wirelmage:
128; Courtesy of Stephen White Management: 15; © WoodyStock/Alamy: 84; © 2008
Alessandro Zambianchi - Simply.it: 122 (Count Panza di Biumo).

Author photograph by James King

Phaidon Press Limited
Regent's Wharf
All Saints Street
London N1 9PA

Phaidon Press Inc.
180 Varick Street
New York, NY 10014

www.phaidon.com

First published 2010
© 2010 Phaidon Press Limited

ISBN 978 0 7148 5709 1

A CIP catalogue record for this book is available from the British
Library.

All rights reserved. No part of this publication may be reproduced,
stored in a retrieval system or transmitted, in any form or by
any means, electronic, mechanical, photocopying, recording or
otherwise, without the prior permission of Phaidon Press Limited.

Printed in China